Painting
with
Elke Sommer

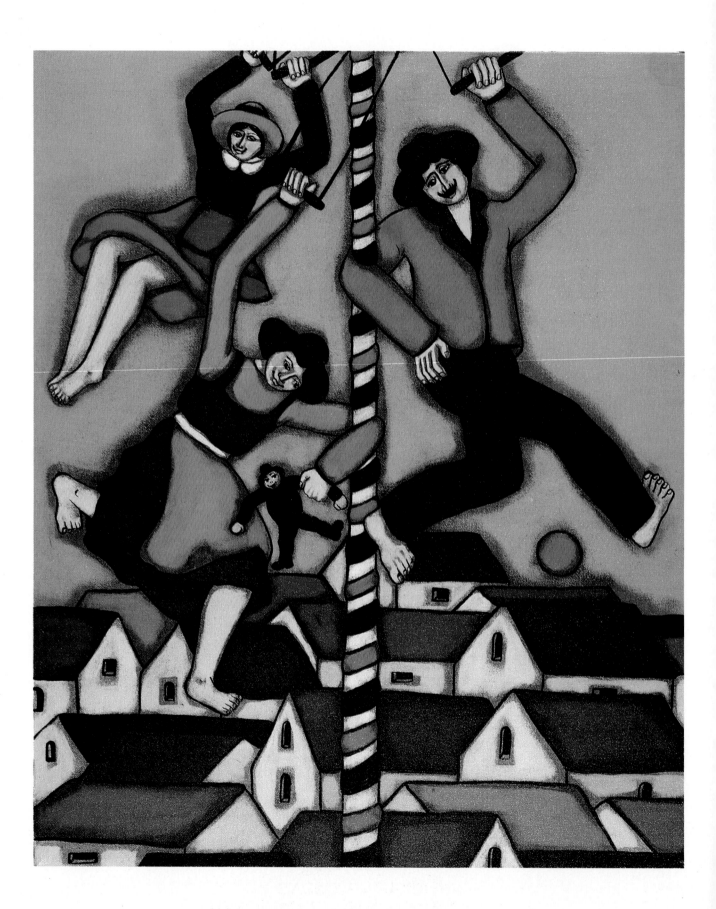

Painting with Elke Sommer

WATSON-GUPTILL PUBLICATIONS
NEW YORK
KOCE-TV FOUNDATION
HUNTINGTON BEACH, CALIFORNIA

Elke Sommer paintings and graphics
represented exclusively by

EDWARD WESTON GRAPHICS, INC.
19355 Business Center Drive
Northridge, California 91324

*Watson-Guptill would like to express its thanks to Rosemary Starace for her
outstanding editorial contribution to this project.*

Elke Sommer paintings © 1984 by Edward Weston Graphics, Inc.,
Northridge, California

First published 1984 in the United States and Canada
by Watson-Guptill Publications,
a division of Billboard Publications, Inc.,
1515 Broadway, New York, N.Y. 10036

Library of Congress Catalog No. 84-40469
ISBN 0-8230-3884-X

Manufactured in U.S.A.

1 2 3 4 5 6 7 8 9/89 88 87 86 85 84

Contents

Preface

One could take for granted that Elke Sommer would be beautiful and charming on television. But that she would also be able to communicate her creative ideas and painting method well might not be quite so evident.

If I had that notion, it was quickly dispelled when I met Elke Sommer and had the privilege of working with her during production of the thirteen programs that make up the public television series "Painting With Elke Sommer," on which this book is based. Not only did her canvases explode with colorful dancing gypsies, leaping cats, vibrant flowers, and appealing country folk, she literally captivated her audience into wanting to try painting for themselves.

How did she do it? I believe the answer lies in her own personal attitude toward painting. Elke paints for the same reason she wants *you* to paint. "Painting makes me happy—and it will make you happy, too, I promise you." As she affirms, "It's the one thing that I can do by myself—where it's all from my own mind, my soul, my imagination."

As I watched her paint, I realized that it is this joy in painting that she communicates to her audience. And the enthusiasm is indeed contagious.

The fun starts with the subject matter itself—warm, loving characters who would be a pleasure to know. Elke's paintings always tell a story, and as you begin sketching, you'll see that she also likes to add a touch of whimsy. Where else can you find a polka-dot Easter egg or a pig that looks suspiciously like a dog? During production, I found myself sharing her enjoyment each step of the way—from delight at the sight of pure brilliant color oozing out of a paint tube, to excitement as she smeared a black watercolor wash on each seemingly finished painting and then, like a great detective, triumphantly wiped it away to reveal her unique method of shadowing.

Each half-hour (the shows were produced "live on tape") seemed to fly by. And like any special visit, I was always left at the end with the feeling of not wanting my friend to leave.

The great value of this book is that it allows you, the painter, to take as much time as you want with Elke's step-by-step, easy-to-follow instructions, to have fun with her techniques, enjoy the reproductions—and to end up with your own successful paintings.

"You'd be surprised at what you can pull out of your head!" Elke admonishes all of us in one of her television programs. After you've accomplished your first "Elke" painting, I think you'll agree.

JOAN OWENS
Executive Producer
"Painting with Elke Sommer"

Introduction

There are many ways to make a painting—as many, in fact, as there are people painting. The special way *I* make a painting is something I've developed through years of experimentation. It's not, of course, the only or even the best way to make a painting. I use it because it's fun, it's unusual, and it produces beautiful results. For those reasons, I'd like to share it with you.

In the following pages I'll give you clear, precise instructions for every step of my general method and for every aspect of each of thirteen paintings. *You* can choose to follow the instructions exactly or use them as a take-off point for your own experimentation. Who knows, maybe you'll discover something equally unique. If you do, let me know!

How to Use This Book

Materials and Techniques

In the first part of this book you will find a list of the paints, brushes, and other equipment you'll need. It's very basic, nothing too expensive or unusual.

Following the list of materials, you will find in-depth instructions on the techniques and methods I use in every painting. There are four phases altogether: sketching, mixing colors and painting in, outlining, and shadowing. Each painting, except *The Village Dance*, *My Last One*, *Umbrellas in Love*, and *Summer Love*, follows the four steps in that order. (The exceptions present slight variations that are explained in the discussions of those paintings.)

Here's a brief overview of each of these four techniques—with some points to keep in mind.

Sketching. This step involves simply drawing your picture on the canvas as a guide for when you paint. For every painting you have the choice of drawing freehand or not. In the back of the book you'll find simplified outline sketches of each painting which you can copy or enlarge if you want.

Mixing Colors and Painting In. This step involves choosing and mixing your colors and, with acrylic paints, painting in the major color areas indicated in your sketch. You can either use the same colors I have used or invent your own mixes. I identify every tube color and tell you how I mix each color, but remember that color mixtures can only be approximate. If you really want to match my colors exactly, use the large reproductions of the paintings as your guide. This will involve some trial and error, but matching colors is really excellent training for your painter's "eye."

If you invent your own mixes, you'll train yourself in another painting skill—color harmony—which is not as difficult as it sounds. Color harmony is simply a matter of *seeing* which colors look good together. You may not realize it, but you do this all the time—when you dress, when you decorate a room, when you make a flower arrangement. Even when you merely respond to a pleasing painting, scene, or set of clothing, it's because you have the innate ability to recognize color harmony. As you experiment, you'll also discover you can use color to express moods or feelings. The possibilities are limitless.

Outlining. In this step you'll add a fine black line around all the figures and objects to make them and the colors stand out boldly. You'll see that you can do this technique with a fine brush or a thin waterproof marker. If you use a brush and paint, you'll get a better quality line, but I admit a marker is much easier to use. Your hand needn't be as steady as it has to be with a brush. I recommend you practice with the brush. Your hand will get accustomed to it more quickly than you think, and the results are worth the extra effort.

Shadowing. This is the most unusual aspect of my technique—and the most fun. Here you put a coat or "veil" of black transparent *watercolor* over your painting, then remove designated areas of it with a wet brush and paper towels. You'll see that the uncovered colors glow even more brightly than before and the shadowed areas that remain add depth and dimension to your painting. The shadowing and outlining techniques together produce an effect somewhat like stained glass. It's gorgeous and very easy to achieve.

This is important: you should read through all the techniques section, make sure you thoroughly understand the procedures, and then practice the various techniques on an extra canvas, canvas board, or heavy paper *before* you actually begin working on a painting.

Even though you're probably eager to start, I urge you to take the time to familiarize yourself with the basic techniques. Have patience! I guarantee that this initial practice will make your painting process more enjoyable and your finished painting more successful. You'll avoid having to make lots of tedious corrections; you can concentrate, instead, on the fun of creating a special work of art.

Now, don't let my stern advice scare you into thinking my method is difficult. It's not, I promise. You must practice any new skill before you master it. And, by the way, you'll learn how you can correct mistakes at any point, so you don't have to worry about ruining your painting.

Painting Demonstrations

When you feel confident with these four techniques, pick a painting that intrigues you and begin. You do not have to start with the first painting and proceed in sequence. Instructions for each painting are complete in themselves, and all of the paintings are about equal in difficulty, so just plunge in wherever you want. The only one I don't recommend you start with is *My Last One*, since that painting departs the most from the usual procedure.

Every painting demonstration is set up in the following way: First, there's a brief introduction in which I tell you where I got my idea, what mood I was after, and what *you* will learn from doing this particular painting. After that, you'll find a list of the specific paints and brushes you'll need.

There's also a short discussion about the composition of the painting. It's fascinating to see how the placement of the figures and objects in a painting can create both mood and movement. You'll be able to use this information in all the paintings you make.

Then the step-by-step instructions begin. You'll see that these follow the same order as the techniques section—sketching, painting in, outlining, and shadowing. Here,

though, you'll find instructions specific to each painting, as well as a condensed summation of the general technique. (If you need to refresh your memory about some detail of the outlining or shadowing procedure, you can simply flip back to the techniques section.)

Every painting demonstration is fully illustrated in brilliant color. In each one there are reproductions showing both preliminary steps and the finished work. These give you a good idea of what your painting should look like as you proceed. There's also an enlarged closeup of some special aspect of the painting so you can clearly *see* what I've been describing. A full-page, full-color reproduction of the painting completes each demonstration.

Tracings

The book ends, as mentioned before, with simplified outline drawings for each painting which you can copy or enlarge. Instructions for enlarging are provided.

I hope you enjoy this book and use it to start yourself off on an enjoyable lifetime hobby—or career. As a final piece of advice, remember that "perfection" can sometimes be boring! Your personal quirks and unique imagination will make your paintings special. So don't worry about your lack of experience, just have *fun*.

ELKE SOMMER

Materials
and
Techniques

Paints and Palette

Here are the Grumbacher Hyplar® acrylic colors I use in the paintings shown in this book. When you purchase your paints, make sure they say *acrylic* or *polymer acrylic* on the label. Since you'll be using a lot of white and black, get them in the larger size tubes.

Mars black
Titanium white
Thalo® silver
Cadmium red light
Grumbacher red
Thalo® crimson
Portrayt red
Hansa orange
Cadmium yellow medium
Yellow ochre
Thalo® yellow green
Permanent green light
Thalo® green
Thalo® blue
Cobalt blue
Grumbacher purple
Burnt umber

HYPLAR

TITANIUM
WHITE
H212

ACRYLIC POLYMER
PLASTIC COLOR
FOR ARTISTS

GRUMBACHER

NET 2 FL. OZ.
(59.1 cc)

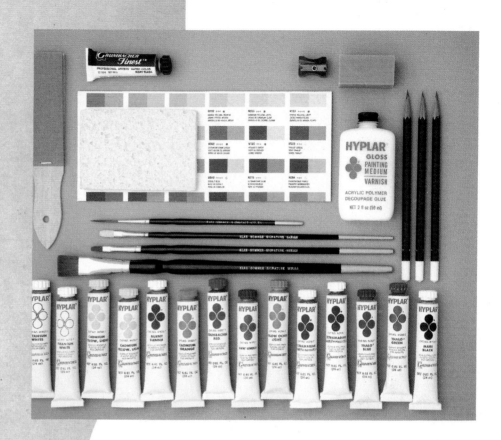

Also get a large tube of *ivory black watercolor*, which you'll need for the shadowing technique.

Note: There are many different shades of each color available. Try as many as you want—substitute them for the shades I've used if you like. You will get *different* results, but you might like them better!

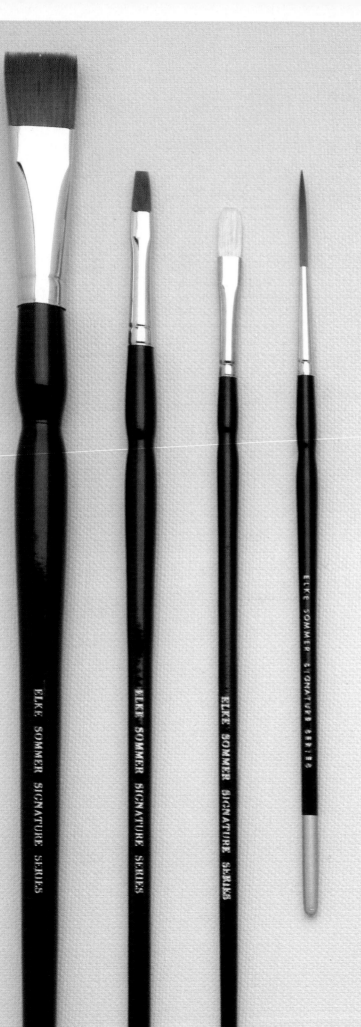

Brushes and Other Equipment

Brushes

Here are the Grumbacher brushes I use. Different manufacturers use different numbering systems, so the measurement in inches is a more reliable guide if you're not using the brushes pictured here. (These special brushes have a unique hourglass shape that gives you improved handling and control. Just hold them, like a pen, at the indentations.)

#20, ¾" soft flat (bright)
#6, ³⁄₁₆" soft flat (bright)
#4, fine-point liner brush
#1, ¼" bristle flat (flat scrubber)

optional
#4, ⅜" soft flat (bright)
#1, ¼" soft flat (bright)

In the text, all the brush sizes recommended refer to the ones I use on my large (24" × 30") canvases. If you prefer to work at the size of the tracings in the back of this book or at any small size, you may sometimes prefer to use a *smaller* brush than the one indicated. I recommend that you also get the optional #4, ⅜" soft flat.

Other Equipment

Prestretched canvas or canvas board: These come already prepared and ready for you to begin work.

Palette or palette pad: I recommend the palette pad. You can throw each

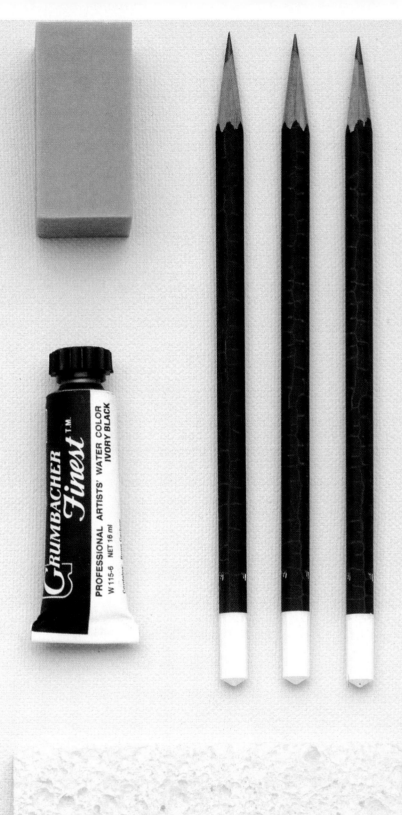

sheet away after a day's use. There's no messy clean-up. Ask for one that's used for acrylic paints.

#2 or #3 pencils: Regular drawing or writing pencils are fine, as long as the lead is neither too hard or too soft. Very soft pencils will smear; hard ones will be more apt to scratch the surface of your canvas.

Hard pink rubber eraser or art gum eraser: These are best for removing pencil lines.

Common household sponge: Get one that you can grip easily in your hand.

Paper towels: Always keep a roll on hand when you're painting.

Water container: Use any *big* jar or bottle.

Pencil sharpener

Optional
Acrylic gloss painting medium: You can mix a little of this with the colors on your palette. It will add a protective shine to your paints, as well as give them a nice consistency.

Acrylic spray varnish: I also recommend spraying your finished, thoroughly dry painting with spray varnish. This will add a shine and protect your delicate watercolor wash from smudging or water damage. Use gloss for a high shine and matte for a soft finish.

Sketching

The first step in making a painting is sketching your composition on the canvas. Even though your pencil lines are ultimately hidden by paint, the sketch is actually about the most important aspect of painting. It is the foundation on which your painting is built. In the sketch stage you create your composition just the way you want it. Since you can erase easily, you can move objects around and test out different ideas that would be much more difficult and time consuming to do at the painting stage. If your sketch doesn't work or doesn't please you, then neither will your painting. So, even though you're probably eager to begin "playing" with all those colors, take the time and get your sketch *exactly* the way you want.

If you were making up your own compositions, you would probably do lots of little sketches on paper first to develop your ideas. Here, since you will be copying or tracing my compositions for the most part, you can begin right on your canvas or canvas board. (See instructions for tracing on page 80.)

Use a #2 or #3 regular drawing pencil. Don't make your pencil extra sharp. A slightly blunt tip is best because it will not scratch or indent the surface of your

canvas. (This is especially a danger on stretched canvas, less so on a board.)

For this same reason, press lightly when you draw. Your lines don't have to be dark or bold. No one is meant to see them but you—and they are going to get covered up anyway! Incidentally, a dark pencil line will show through certain colors. Dark lines are also harder to erase.

So, start making your sketch. Begin with the main figures and objects, then do the background and less important elements. You can sketch roughly at first, then refine it. Erase all you want. (Remember, *light* pencil lines erase easily.) Always remember to brush away all the little eraser crumbs as you go. If there are any left on the canvas, they will spoil the smoothness of the paint.

Draw in the basic shapes first—the ones you are going to paint in. Leave all the little details, like faces and fingers, till later. You will sketch them in *over* your paint when it's dry. By the way, you can erase on a painted surface, too.

When your sketch is all done, you are ready to begin painting.

Mixing Colors and Painting In————————

This, I think, is everybody's favorite part—watching those fantastic colors magically combine into even more amazing shades and then transforming a blank white canvas into a colorful *painting*.

The techniques I use for mixing and applying my colors are very simple. Before you start, have all your clean brushes, your palette pad, and your paints on hand. Also have a large jar of clean water nearby—and plenty of paper towels.

Mixing

If you are going to use a color straight from the tube, squeeze the amount you need onto your palette. Dip your brush in water, tip it on the side of your water jar so it's not too wet, and swirl it around in the paint a few times until you have a nice, even consistency. You do not have to thin acrylic paints. This tiny amount of water is usually all you need.

If you are mixing two or more colors, squeeze out all the colors you'll be using for the mix in the amounts you need. Usually there will be one basic color to which you'll be adding small amounts of other colors. Let's say you are mixing a light blue. You'd have a large amount of white on your palette and a small amount of blue. (Specific instructions for each color mix you'll need are given in the lessons.)

Wet your brush as described above and dip it into the blue, picking a little of it up on your brush. Now place your brush down right *next* to the white and pick up a little at a time, mixing as you go. This way you can *control* the mixture. If you immediately mixed *all* the blue into *all* the white, you probably wouldn't get the shade you wanted. You'd have to stop, squeeze out more paint, try again. By mixing a little at a time, you can watch your color appear gradually, avoid mistakes, and save paint.

Mix your paints together thoroughly. The color should be uniform, with no streaks. Make sure you start with a clean brush any time you mix or use a new color. Just rinse your brush out in water and blot it dry on a paper towel. If you ever need to match a mix to a color you've already applied, remember that wet paint looks slightly lighter than dry. Don't get discouraged if your mixes don't match mine perfectly. Color mixing can't always be exact, and besides, experimentation is part of the fun.

Painting In

Now you're ready to apply your colors. Pick up a generous amount on your brush. The paint should cover more than the tip, but avoid big blobs of paint which cover the bristles entirely. You will use a large brush for large areas, like a background, and smaller brushes for small areas.

Apply the paint to your canvas with broad, long strokes—not short little dabs (Fig. 1). Keep picking up more paint as you need it. Use lots of paint! Smooth out any little "ridges" that appear by stroking them lightly with your brush.

When you are painting the edge of some shape, place the tip of your brush down firmly next to the edge and stroke confidently, following the shape of what you are painting (Fig. 2).

When you are painting in very small spaces, you will obviously put less paint on your brush and make shorter strokes than when you are filling in large areas.

In general, start at the top left of your canvas and work across and down. Paint the background in first and work your way forward. Sometimes, if you have lots of the same color at different places on the canvas, it's practical to mix a large batch of that color and paint all those areas at the same time. *Clean your brush every time you change colors.* Change the water in your water container when it starts to look muddy.

If any areas should need a second coat, the paint must be dry beneath it. If it's still a little sticky, a second coat will pull up the underlayer and create annoying little blobs of paint. Usually a ten-minute wait is long enough.

When you're painting an area adjacent to one that's already painted, the paint must be dry enough so that you don't accidently mix your colors at the edges. Usually five minutes is enough drying time for that—but it depends on how thickly you've applied your paint. Experience will teach you best. If you do make a mistake, just wait till the mistake is dry and paint over it. No problem!

When your entire canvas is covered—and dry—you can go back and touch up wherever necessary. Minor irregularities along the edges of your shapes can be fixed in the outline and shadow stage, so don't worry about them.

One important fact about acrylic paints: *they dry very*

quickly. Never leave your paint-covered brushes out in the air for more than a couple of minutes. If you're not painting with them, they should be in water. Paints also dry quickly on your palette, so don't squeeze out more than you are going to need for the moment.

When you are through for the day, throw your used paper palette away and clean your brushes well. Use running water and a little plain soap. Make sure no paint remains where the bristles attach to the handle. Let your brushes dry standing, tips up, in a can or jar.

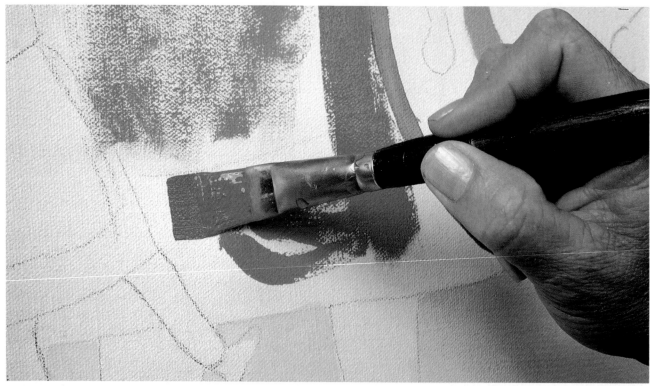

(Fig. 1)

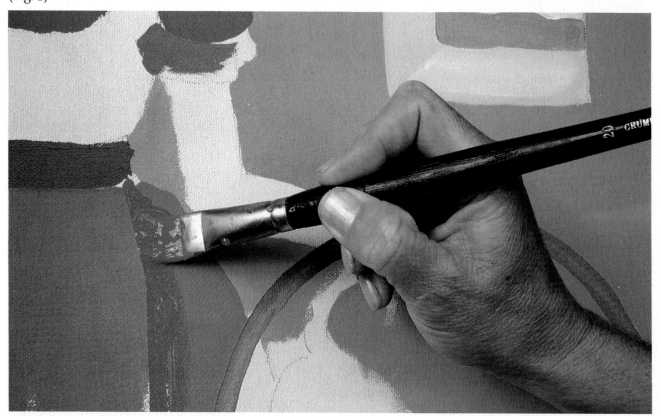

(Fig. 2)

Outlining

Once all the paints are completely dry, you're ready to go on to the third stage: outlining.

When you work with broad, flat areas of color, outlining is a very effective way to make each colored area stand out and grab your viewer's eye. It actually has the same function as eyeliner or mascara—giving your colors, like a woman's eyes, more allure, vibrancy, and boldness.

Here are the step-by-step directions:

1. You'll need a #2 or #3 blunt pencil, an eraser, your liner brush (#4), and a tube of Mars black *acrylic paint* or a fairly thin *waterproof* marker pen. Your canvas can be horizontal or slightly tilted, depending on which is most comfortable for you. Feel free to move your canvas around as you work. Often, turning it will make it easier to paint in your lines.

2. Begin by carefully sketching in faces, fingers, toes, buttons, and any other interior details you want to indicate with a black line. If you want, also pencil in *all* the outlines around your figures, their clothes, animals, houses, trees, and so on, to give you a reliable guide for painting later. You can erase all you want—just make sure you brush the crumbs away before you paint. Now, before you do your black outlines, paint the eyes in with titanium white using your liner brush. Rinse your brush well and paint the irises any color you want. Just be sure the white is dry before painting over it. Rinse your brush again *very well*.

3. Squeeze a medium-sized blob of Mars black *acrylic* onto your palette. To get the right consistency, you may have to add a few drops of water and mix thoroughly. (Use one of your other brushes to mix—not your liner.) Now, using your liner brush, experiment on a piece of paper to see if the paint consistency is all right. It should be thin enough to flow on smoothly and easily in a solid, unbroken line, but thick enough so that it doesn't run down or bleed sideways.

4. Before you work on your canvas, you should also practice your brushstrokes. Even if it seems difficult at first, you must act *confidently* with your brush. Make long, smooth, steady, continuous strokes. Try to do the entire length of a pants leg or skirt or side of a

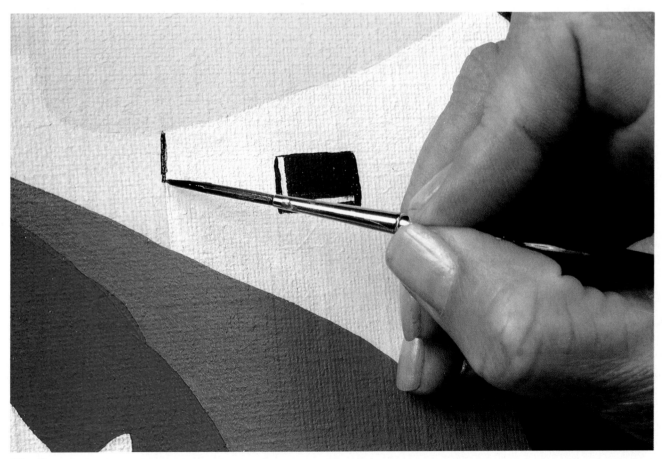

(Fig. 1)

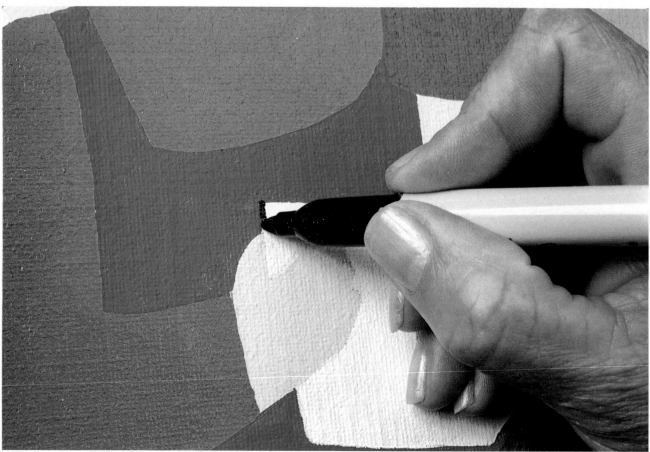

(Fig. 2)

house without stopping. In other words, stop only at corners or where the line changes direction. You don't have to work *fast*, just smoothly. If you make short, jerky strokes, or if you stop and start a lot, your line will look fitful and shaky. Even if you use a marker, this will hold true.

5. Now you're ready to work on the real thing. Remember, smooth, steady strokes—with brush or marker (Figs. 1 and 2). You'll probably find that initially you have more control and steadiness with a marker. I use a marker sometimes but, really, a brush is a more satisfying challenge and ultimately will give you *more* control. If your hand is unsteady, rest it on the canvas as you work. Just make sure any painted areas or outlines beneath it are dry. A good way to avoid smearing what you've done is to work from left to right and top to bottom (right to left if you are left-handed). If

you do smear an outline or make a mistake, wipe it away *immediately* with a damp paper towel. You can also paint over any areas you've "messed up," but try to avoid that—it's tedious. Now is the time to put in any other black details your painting might require, such as eyebrows, pupils, buttons, and so on.

6. There are two more tips to remember when outlining. If your brush or marker "skips," that is, if you don't get that smooth, solid outline in some places, don't despair. It will get filled in and smoothed out when you apply your black wash in the final stage. Also, as you get really skilled in outlining, you may want to slightly vary the thickness of your outlines where appropriate. For instance, a line that looks thin and delicate outlining pants or a skirt may look too heavy and dark around an eye. Experiment. *See* what looks best.

Shadowing

This final "Elke technique" is very, very special. As far as I know, only I—and now *you*—know how to do it. It produces *the* most professional-looking results, and it's easy and fun, too.

Wait till you experience the shock of seeing the painting you've just worked so hard on covered entirely with black! And wait till you see how pure and brilliant the colors look as they start to emerge from the shadows! Although I've done this process hundreds of times, it *never* fails to thoroughly excite me. I'm so pleased to be sharing it with you. I know you will find lots of pleasure and a sense of great accomplishment.

Here's how to do it, step-by-step. Read through all the instructions before you begin.

1. You'll need a common household sponge, lots of paper towels, a tube of ivory black watercolor paint, and a flat bristle brush (#1, ¼"). Your canvas should be *thoroughly* dry (wait at least one hour), and you should work on a *horizontal* surface.

2. Begin by dampening your sponge. Sprinkle water on it with your fingers, lay a paper towel over it, and blot it with the palm of your hand. If the water soaks through immediately, the sponge is too wet. If no wetness appears, it's too dry. The paper towel should look splotchily wet after you blot it. Experimentation is the only way to get this right.

3. Now take your ivory black watercolor and put five or six evenly separated, tiny blobs of paint on your sponge (Fig. 1). Use any *clean*, moistened brush and smear the blobs evenly onto the surface of the sponge (Fig. 2).

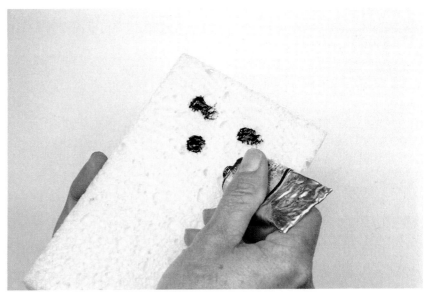

(Fig. 1)

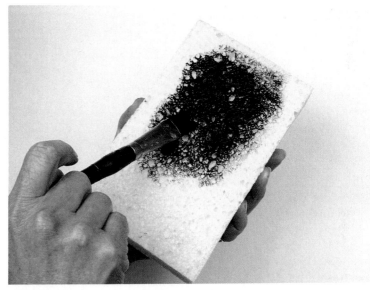

(Fig. 3)

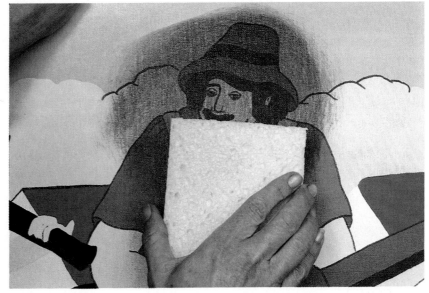

(Fig. 2)

21

4. Here comes the fun part. Take the blackened sponge and rub it with smooth circular motions over the *entire* surface of your canvas (Figs. 3 and 4). It's shocking, no? If the black doesn't cover well or if it looks very dark, your sponge is too dry. If the wash runs or streaks or puddles, it's too wet. In either case you can remove the wash easily with a clean sponge or damp paper towel and try again. The perfect wash looks unstreaked and evenly colored—like a film or veil.

(*Note:* If your painting has a big empty background, you don't need to apply the black wash over all of it. Just be sure the shadow extends about an inch beyond the figures and objects.)

When you get more experienced with this technique, you can experiment with the darkness and lightness of the shadow by using more or less black watercolor or more or less water on your sponge. Some paintings will seem to need a lighter overall wash than others. You do what *you* think looks best.

5. Let your wash dry for a few minutes. Then take your flat *bristle* brush (#1, ¼″) and dip it in clean water.

In general, start working from left to right and from the top down *on the lightest areas first*. If you're left-handed, work from right to left, so your hand doesn't smear what you've already done as you move across the canvas. It's best to work on the light colors first because, as the wash gets drier, a pale black residue settles in the texture of the canvas, making the wash difficult to remove.

With your moist brush, "paint" over the black wash you wish to remove. Use the tip of the brush,

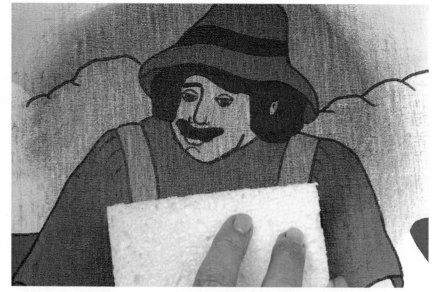

(Fig. 4)

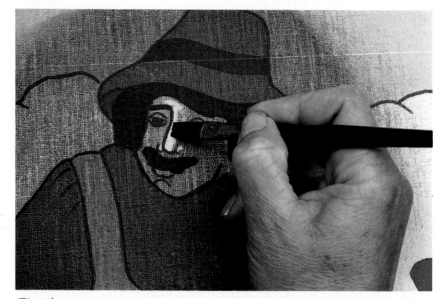

(Fig. 5)

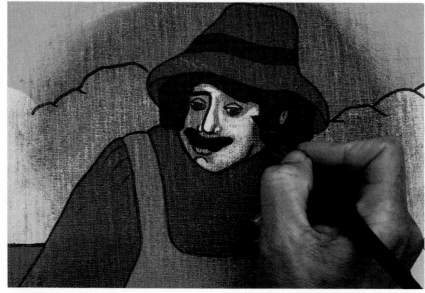

(Fig. 6)

held upright, to get into very small areas or to control your edges (Figs. 5 and 6). You may have to stroke back and forth a few times for the wash to come up—or use more water. (Isn't it wonderful when the colors reappear? They look even brighter in contrast with the shadowed areas.)

If the area you are working on is very large, you don't need to use a brush. Just wrap your index finger in a wet paper towel and remove the shadow by rubbing. Then continue the shadow removal process as instructed in the following steps.

If the water runs or spills over into the shadow you want to keep, your brush is too wet. Just blot the canvas with a paper towel and tip your brush on the edge of your water container to remove the excess moisture. Reapply the wash in that area if necessary.

Important! Except in special cases, always leave an edge of shadow (⅛″ or so) along both the inside and the outside of all your outlines. This is important to get the full effect of the shadowing technique.

6. Now take a clean, just slightly damp paper towel (sprinkle with a *little* water first) and blot lightly on the area you've just worked on (Figs. 7 and 8). The purpose is to pick up the excess moisture. When you've done this, your surface may still look a little veiled or splotchy. That's all right; just go on to the next step.

7. To complete the shadowing process, take another clean, moist—not wet—paper towel and wrap it around your index finger. If the area is large enough, just rub

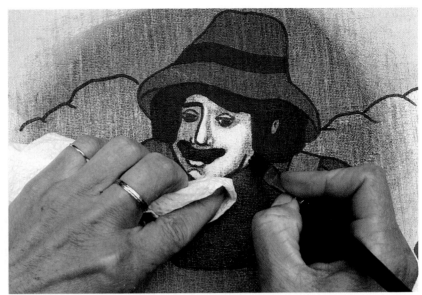

(Fig. 7)

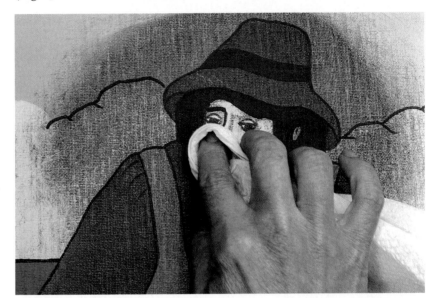

(Fig. 8)

(Fig. 9)

over it with your finger, pressing harder than before. This will remove any residue that's left (Figs. 9 and 10). If the area is too small, you can apply a *little* more water with your brush and blot again till it's clean.

Note: Repeat steps 5–7 on every portion of your painting.

8. When you are all through, you may want to smooth out or slightly lighten your shadow in certain places or overall. To do this, take another slightly damp paper towel and rub it very lightly over both the empty and shadowed areas. This will soften the edges of the shadows as well as even out the texture.

(Fig. 10)

Painting Demonstrations

Circus Dreams

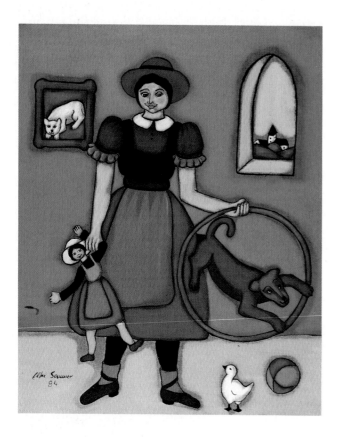

Introduction

If you're starting here at the first lesson, this might be your first time painting—how nice! I imagine you must be thinking, "How am I ever going to make a painting appear on this empty and intimidating white canvas?" Don't worry. We'll go through every stage step-by-step. And just as this young girl in the painting is dreaming her exciting dreams of the circus, *you* dream of the wonderful paintings you'll be making.

Equipment

Acrylic Paints	Brushes
Titanium white	# 20, ¾" soft flat
Mars black	# 6, ³⁄₁₆" soft flat
Cadmium red light	#4, fine-point liner brush
Grumbacher red	#1, ¼" bristle flat
Thalo crimson	
Hansa orange	*optional*
Yellow ochre	#4, ⅜" soft flat
Permanent green light	#1, ¼" soft flat
Thalo blue	
Grumbacher purple	

Watercolor paint
Ivory black

Procedure

Before You Begin

It's always important to think about the composition of your painting before you begin. *Where* you place your figures, animals, windows, and so forth can make the difference between a painting that works and one that doesn't. One good general rule, illustrated by our circus girl, is to approximately center the most important figures and use other, less important elements to fill up and "activate" the outer areas of the canvas.

Sketching

Whether you use the tracings provided in the back of this book or try a version of your own, take time with your sketch. It's the foundation of your painting and it should be just the way you want. You can sketch directly on your canvas or board and erase to your heart's delight. Just remember to brush away the "crumbs" completely. Leftover crumbs will spoil your paint.

At this point skech in only the main shapes—save details like facial features and fingers till after you paint. See page 16 for tips on sketching and page 80 for instructions on tracing.

Painting In—Background

When your sketch is finally pleasing to you, the *artist*, it's time to start mixing your colors. In this case, you'll begin with the background. The wonderful wall color you see here is made from three different colors. Squeeze these out separately on your palette: a big dab of titanium white, a small dab of Thalo blue, and a tiny dab of Thalo purple. With your moistened, clean #20, ¾" flat, soft brush, add a little blue and even less purple to the white. Swirl the colors around with your brush till they are evenly mixed. Use as much blue and purple as you need, adding a little at a time, to get a color that matches this one—or one that you like better. If your mix gets too dark, just add white.

Now you can begin applying the paint in broad, generous strokes, as described on pages 17–18. Use the broad part of your brush for wide areas and use the edge or tip for small areas and accurate edges around the girl and the other objects in the painting.

To mix the color for the floor, use a medium dab of yellow ochre and about twice as much white. Add just a minute touch of Grumbacher red.

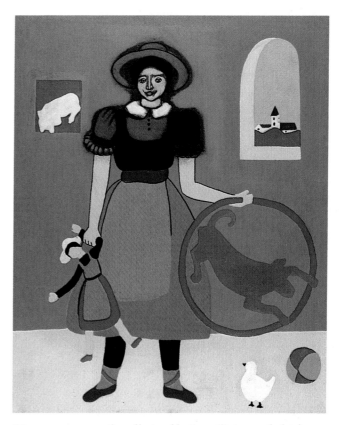

Here the painting in is almost complete, but some of my edges need touching up. A few will need painting over, but most I can straighten out when I do the outlining. Keep that in mind when you work. Lots of imperfections can be fixed that way.

Figure and Objects

You'll use exactly the same procedure to paint the figure and objects. Your main concern will be how to mix all the lovely colors you see, and I'll give you instructions for every one.

First, here's a tip that will save you paint. When you've mixed up a color that appears in more than one place, paint all those at the same time. Of course, sometimes you may choose colors or change your mind as you go. But if you're sure in advance, this is a good way to work.

Here are the color mixes. Of course, you can invent your own if you want.

Girl's blouse, waistband, shoes, roofs on houses: cadmium red light straight out of tube.

Girl's skirt: equal amounts of Hansa orange and titanium white, plus a slightly smaller amount of cadmium red light.

Girl's hat: white and Thalo crimson in a ratio of about 2 to 1.

Girl's apron: equal amounts of white and Thalo crimson.

Girl's socks, ruffles on sleeves, doll's apron: titanium white with a small amount of cadmium red light.

Dog, picture frame, sleeve bands, doll shoes, girl's ankle straps: Mars black and titanium white, about half and half.

Hoop, doll's skirt, ball, hills, picture background: permanent green light and yellow ochre in a ratio of 2 to 1.

Sky: titanium white with a speck of Thalo blue and black.

Cat, duck, doll's hat, girl's collar: titanium white.

Flesh tones: big dab of titanium white, small dab of yellow ochre, a touch of Grumbacher red.

Hair, stockings, hat band, jumper top, etc.: Mars black.

When you're all done with this stage, it's advisable to take a long break or even stop for the day. Rinse all your brushes out well; arrange them to dry tips up in a can; and close the caps on your paints securely.

Outlining

With all the painting done, you're ready for outlining—an impressive technique that will make your colors stand out boldly. Before you start, make sure your painting is *dry*. Wait at least one hour, preferably longer.

Here you can see the effects of both outlining and shadowing. See how much stronger and solid the outlined areas look compared to the places that aren't done. And see how the shadowing adds even more vibrancy.

27

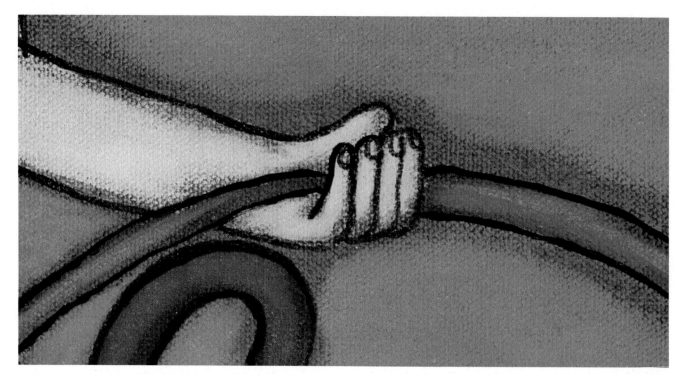

Detail: Hands. Before attempting to sketch or outline hands, look in the mirror at your own. Pose yourself like the girl in the picture. Notice how your fingers curve upward; how you see the sides of your fingers as well as the fronts; and how there's a little space on the side of the finger before the nails begin.

First, take up your pencil again and sketch in the details: the facial features of the girl, the dog, and the cat; the ruffles on the sleeve, the buttons on the shoes, and so on.

In sketching children's features, remember that children's eyes are always lower on the face than an adult's—about halfway down from the top of the head. Also remember you *never* see the whole circle of the pupil or iris—just a little more than half. For animal faces, remember that their eyes are usually high (about one-third of the way down from the top of the head) and a little slanted; their mouths and noses are lower than a human's. If you want, also draw pencil lines along all the edges you're going to outline to provide a precise guide for painting.

Now squeeze a medium-sized blob of Mars black onto your palette. Use your #4 liner brush. (See pages 19–20 for exact instructions and helpful hints.) Start at the top left, outlining the cat picture first. Make long, steady strokes. Practice on a separate sheet until you feel confident.

Make sure you have outlines along all the outside edges and along the interior edges where two colors meet (for example, between the girl's apron and skirt). Also use your black paint and liner brush to add those extra touches you've already sketched in—tiny buttons, windows on the buildings, fingernails.

Rest your hand on the canvas to steady it, but make sure the painting is dry underneath. And don't forget to clean your brush when you're done.

Shadowing

This is the most exciting part of all—the last stage before completion and the one which really adds pizzazz *and* professionalism to your painting. Look at the finished painting on the next page and see how it adds depth to the surface and intensity to the colors.

When your outline has dried for at *least* one hour, take your sponge and prepare it as you learned to do on page 21. Then rub the blackened sponge over your painting in soft circular motions. The idea is to get a smooth overall shading. Don't be alarmed! This does not ruin your painting at all. You've just prepared it to be *even* better.

Let the wash dry for just a few minutes. Then take your wet #1, ¼" flat bristle brush and begin removing the shadow from the lightest areas first (flesh, floor, white animals, girl's collar, sky).

Dab each area lightly with your slightly damp paper towel. Then wrap a clean, damp paper towel around your index finger and rub a little harder—to remove the last remaining residue of black.

Now finish the girl's face and clothing. When shadowing the face, leave a little darkness around the eye areas, but remove all the shadowing from the cheeks.

Remember the number one rule: Always leave a thin border of shadow (about ⅛") around *all* the edges, inside and outside. Leave a thicker shadow on the bellies of the dog and cat.

I think you'll find this shadow technique fun. I always enjoy it because I get to "ruin" my painting with a black, sooty covering and then bring it back to glowing life.

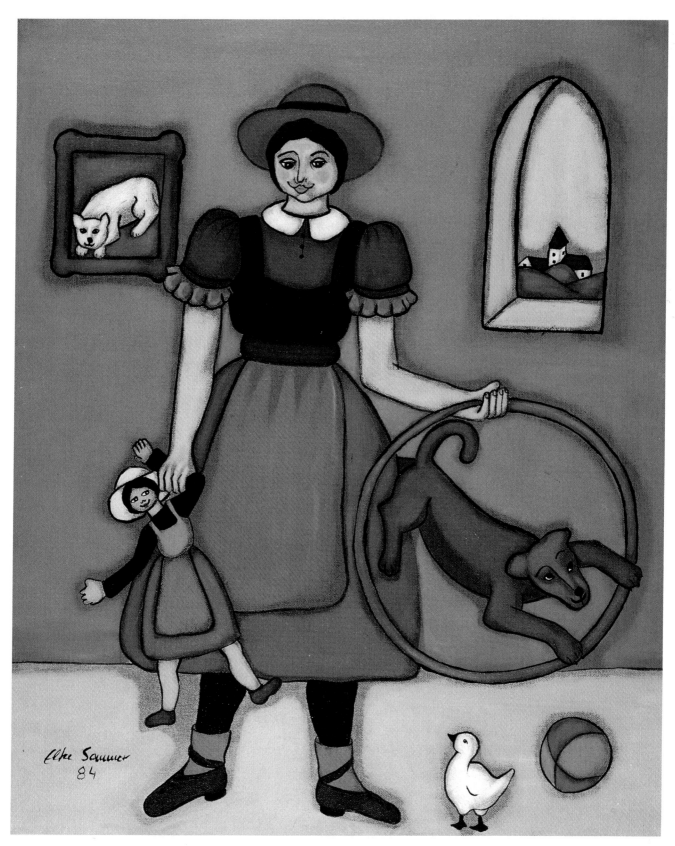

Finished painting. This painting has lots of wonderful color mixes and combinations which you will learn to make.

Swinging Gypsies

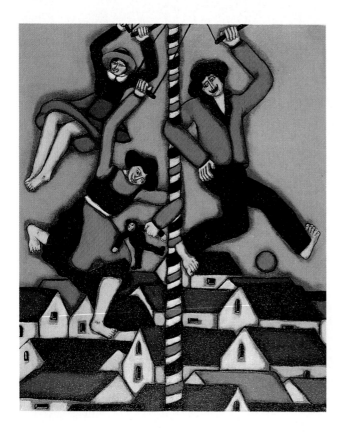

Introduction

Have you ever wished you could dance around a maypole or "fly" above rooftops? The great thing about painting is that you can give life to even your most impossible fantasies. You'll find you can paint the strangest people doing the most fantastic things—in a way that's totally believable.

You'll also see how to mix beautiful grays that look surprisingly festive, not gloomy.

Equipment

Acrylic paints	Brushes
Mars black	#20, ¾" soft flat
Titanium white	#6, ³⁄₁₆" soft flat
Cadmium red light	#4, fine-point liner brush
Grumbacher red	#1, ¼" bristle flat
Hansa orange	
Yellow ochre	*optional*
Thalo blue	#4, ⅜" soft flat
Grumbacher purple	#1, ¼" soft flat

Watercolor paints
Ivory black

Procedure

Before You Begin

This composition focuses around a very obvious center—the maypole. If you look carefully, you'll also see that the figures are drawn in such a way that your eye moves round and round in a circle—giving you the sensation that the people *are* actually dancing! How is this done? It's easy—colors are repeated in different places, forcing your eye to jump from pink to pink or gray to gray, while the arms, legs, and heads act like directional pointers leading your eye from figure to figure.

Compositional "tricks" sometimes seem really magical. Why don't you try to devise a circular composition of your own?

Sketching

On your blank canvas start sketching the child on the top left with a slightly blunt pencil. (See page 16 for detailed information on sketching.) If you're working freehand, you can do a lot of odd posing in front of your mirror to get your figures right. Even if you use the tracings at the back of this book (see page 80) try studying yourself in the mirror. It's fun and you'll learn that observing and noticing the way things really look will help your drawing immensely.

Don't spend time getting your figures *exact*. So what if their arms or legs are too short or long! This makes them interesting, unique, and personal—so much the better. If you do need to erase, go right ahead. But remember to remove the eraser crumbs before you paint.

Use a ruler for the rooftops if you wish, but even here slight irregularities are more visually interesting. Also, leave the facial features and other small details until later.

Painting In—Background

Here you'll get to mix your first beautiful, tinted gray. The surprise is that it's not made from just black and white but contains touches of *purple* and *blue*—which contrast so stunningly with the salmon pink.

Start with a big blob of titanium white on your palette and small blobs of Mars black, Grumbacher purple, and Thalo blue. With your wet #20, ¾" soft flat brush, mix just a little black and equal touches of purple and blue into the white. Add a little at a time until you obtain a pale but not weak sky color like the one I've used. Paint in carefully around your figures. (See pages 17–18 for detailed instructions on painting in.)

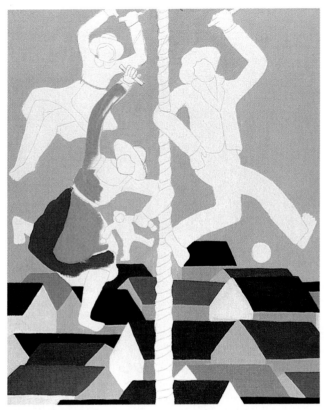

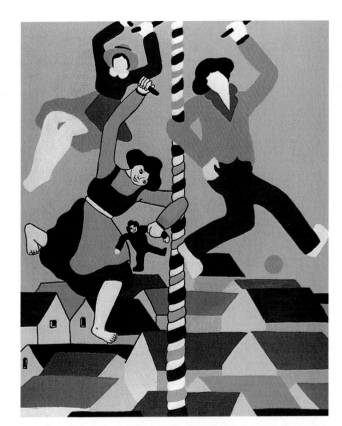

I've finished my sketch and my background and I've started working on the figures. You can really see the purple tone in the girl's skirt here. Later I changed my mind and painted over it with a darker, bluer gray.

Here I've started outlining. The biggest difference, I think, shows up in the maypole stripes. Notice how much bolder they are when outlined.

For the rooftops, you can be wild as the gypsies. Mix three or four different shades of gray (using different ratios of white to black) and add different amounts of purple and blue to each mix. Your purple/blue accent can be subtle or really visible—it's up to *you*. Use your #6, ³⁄₁₆″ brush here since you're working in smaller areas. For best results, repeat each individual shade on at least two or three rooftops in different places. The houses themselves are white. To learn how to make the windows, see the detail on page 52.

Figures

You can go back to your larger brush for the figures. To prepare your colors for the clothing, start with a large lump of black and smaller separate blobs of white and purple.

The girl's shirt, the man's pants, and the two dark hats are a very deep gray—black with just a touch of white mixed in (and purple and blue if you like). When you're mixing on your palette, don't mix all the white into all the black at once. Just add a little white at a time to a portion of the black. You can control your mixing better and use less paint.

The man's collar and the girl's dress are the same tinted gray with slightly *more* white added. The girl's apron color contains even more white. Again, the amount of blue or purple you use is up to *you*. I've

used just a speck—so you can barely see it in the gray.

Now here's how to mix that amazing salmon color: squeeze out a large dab of white, about half as much cadmium red light, and a small amount of Hansa orange.

For flesh colors, mix a little yellow ochre with a large amount of white. Add a touch of Grumbacher red. Here you might want to use the smaller brush again.

The little doll or monkey is black, as are the stripes on the maypole, the trapezes, the windows on the little houses, and the man's moustache. Use your smallest flat soft brush to paint these.

Outlining

There's much to outline in this painting. Don't forget any of the rooftops or the stripes on the maypole. Notice how the salmon and black stripes of ribbon bulge outward from the white pole—a very realistic touch.

Before you begin, make sure your paint is dry. Wait *at least* one hour. Draw in the faces and fingers and toes in pencil first. It's a good idea to resketch *all* the outlines at this point. They'll give you a reliable guide for painting those delicate black lines. For the trapeze wires you can use a ruler to make your lines very straight and "taut."

Since the figures' heads are facing in all different

Detail: Eye highlights. The placement of eye highlights depends on the direction the eyes are looking. If the eyes are looking down and to the left, the highlight should be placed in the upper right of the iris. If they are looking to the right, place the highlights on the left. To make highlights, use your liner brush and touch down lightly with a little pure white.

directions, turn your canvas around so they each seem upright when you sketch and outline the features. Notice that the girl and woman are not quite full-faced. Their heads are slightly turned. Sketch the features slightly to one side—in the direction the head is turned. Don't put the nose in the middle as usual. (See the detail above to learn how to highlight the eyes.)

Don't forget—use your Mars black *acrylic* and your liner brush to outline. See pages 19–20 if you have any questions about the technique.

Shadowing

When your outline has dried for at least one hour, it's time to prepare for shadowing. You'll be pleasantly surprised at how even the grays glow and vibrate more when they are shadowed like this.

Take your damp sponge darkened with black watercolor (see page 21) and rub lightly over the whole surface of the canvas until the black looks smooth and unstreaked. Let it dry for a few minutes.

Use your #1, ¼″ flat bristle brush and begin removing color from the lightest areas first, working from left to right and top down. Complete each section fully—blotting with your paper towel—before moving on to the next. Study pages 21–24 to review the techniques.

Notice there are *no* shadows left around the wires of the trapeze. When you do the faces, remove a *thin* strip of shadow from the cheeks, forehead, and chin. Leave the eye area dark and a strip of shadow under the necks.

Don't forget to close your paint tube caps securely. Acrylics and watercolors dry out *fast*. If a tube does get clogged, use the handle of your brush to push through the hardened paint.

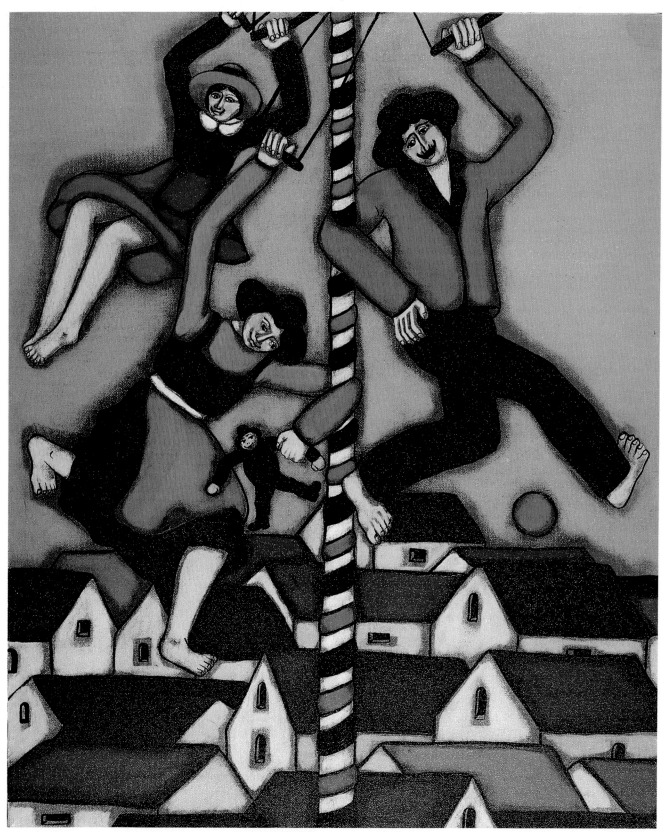

Finished painting. Swinging Gypsies is a lively, active composition that will give you confidence drawing and painting people—and teach you to mix lovely purple grays and salmon pinks.

Easter Tulips

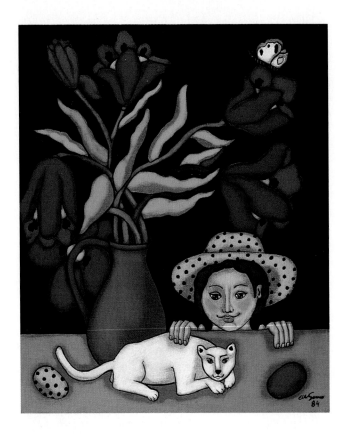

Introduction

When you think about happy colors, you don't usually think of black. In this painting you're going to see that even large amounts of it can produce quite a cheerful effect. If outlining in black enlivens your colors, a whole background of it will make them positively glow.

Equipment

Acrylic paints	Brushes
Titanium white	#20, ¾″ soft flat
Mars black	#6, ³⁄₁₆″ soft flat
Cadmium red light	#4, fine-point liner
Grumbacher red	brush
Portrayt red	#1, ¼″ bristle flat
Cadmium yellow medium	
Yellow ochre	*optional*
Thalo green	#4, ⅜″ soft flat
	#1, ¼″ soft flat

Watercolor paint
Ivory black

Procedure

Before You Begin

Here is another painting, like *Swinging Gypsies*, whose composition is primarily circular. The long, curved green leaves seem to revolve lazily, as a wind-mill would, while your eye flits from flower to flower, much as the little white butterfly in the painting would. Also notice how the red egg in the corner brings your eye down to what could have been a dead spot in the painting. It unifies the upper and lower halves of the composition. In the same way, the speckled egg "echoes" the girl's polka-dot hat and the white butterfly "echoes" the snowy cat. Actually, I put in the two eggs and the butterfly as an afterthought because the composition needed more unity and movement.

Sketching

If you're working freehand, you can have lots of fun with this one. Draw flowers like mine or the ones you see in a garden—or make up the most fantastic-looking flowers you could ever imagine. If you use the tracings, you might want to trace everything *but* the flowers. That way you can be sure you get the sketch right and still have the fun of creating your own special flowers.

Use a #2 or #3 pencil (not too sharp) and erase all you want—as long as you brush the crumbs away. Look in the mirror to get the hands right. You can put in the details on the flower petals, but leave both the girl's and the cat's faces blank for now. See page 16 for tips on sketching and page 80 for instructions on tracing.

Painting In—Background

As you can see, the background here is just a bare, stark Mars black, straight out of the tube. Squeeze a big blob onto your palette. Use your large #20, ¾″ flat soft brush; thin your paint with a few drops of water if it does not flow from your brush easily. Don't forget, use the *tip* of your brush to do the edges of the flowers, leaves, and vase and those tight, small areas. You can switch to a smaller brush for the really tiny areas if you want. Rinse your brush out well when you're done.

For the table, add a little dab of black to a medium-sized dab of titanium white to match the gray you see here. You will not need much black to mix this light gray. If you make a mistake and the color gets too dark, just add more white. Use the same size brush as you did for the black background.

Review the basics of painting in on pages 17–18 if you have questions.

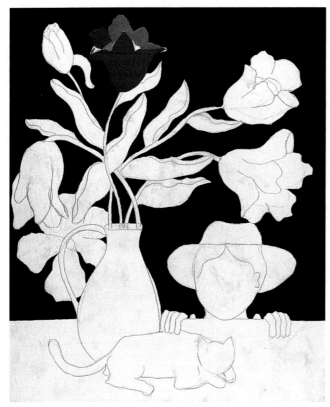

Here I've just begun to paint the flowers with those gorgeous reds and pinks. I forgot to wait for the red to dry before I added my yellow center; see how it turned orange.

Flowers, Leaves and Vase

For the flowers, squeeze out a medium-sized blob of cadmium red light and a separate, smaller blob of titanium white. Dip your #20, ¾″ brush in the pure cadmium and start painting the upright flower in the top middle (see illustration above). Use the tip of your brush to get clean edges. Paint in only the lower three petals and the small upper petal on the left. Now pick up some white on your brush and add it to the red—to mix that deep shade of pink. Paint in the rest of the petals. Leave the spaces for the yellow centers blank, but paint over the spaces for the black shapes; you can put them in later.

For the other flowers, paint the outside petals pure cadmium red light and the inner petals pink. You can also mix a darker pink using less white, and alternate the pinks on the inner petals. For the little bud at the top, I used only the two pinks—no red. When the red is *dry*, paint in the yellow centers. Leave the black till the outlining stage.

For the leaves I used Thalo green mixed with the tiniest touch of white in the darker green portions and Thalo green mixed with a lot of white (about half) in the lighter green portions. For the stems I added a touch of cadmium yellow medium to the darker mixture.

The vase color is mixed from Mars black and titanium white (about half and half).

Girl, Cat, Eggs and Butterfly

Paint the girl's hat with pure cadmium yellow medium, using your #6, ³⁄₁₆″ soft flat brush. The hat will need two or three coats of paint, especially if you go over the edge of the black. Paint the yellow egg in too. Don't worry about the polka dots yet. For the hair, use a little Portrayt red. You may want to use a smaller brush here. For the flesh color, mix titanium white with a little yellow ochre and a touch of Grumbacher red.

The cat and the butterfly wings are just pure white. The butterfly body is the same dark gray as the vase. Add a couple of squiggly yellow and black dots to the wings.

Outlining

When the paint is thoroughly dry (one hour at the very least), pick up your pencil and sketch in all the lines you are going to paint: around all the objects, in between the petals, between the dark and light portions of the leaves, and so on. If you feel your hand is steady enough to do without these penciled guidelines, that's fine.

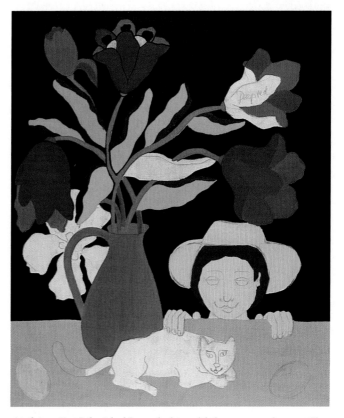

At this point I decided I needed to add the eggs and was still thinking about the butterfly. Because I painted over two dark surfaces, I had to give both the butterfly and the eggs several coats of color.

35

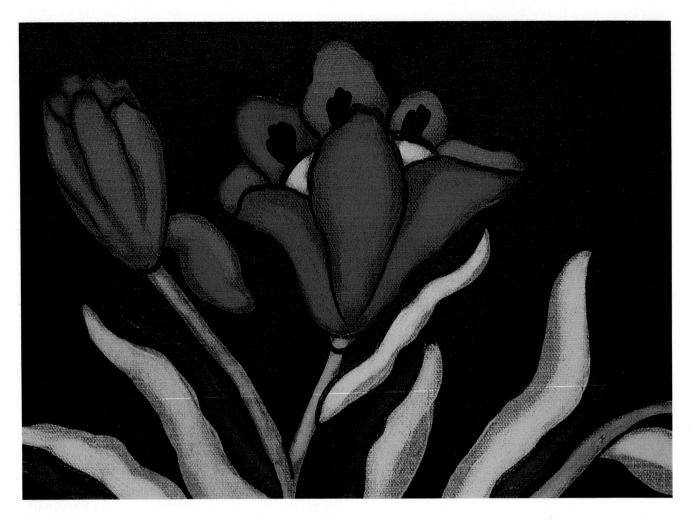

Detail: Flower. Here's a closeup of the top flower so that you can clearly see what's described on page 35.

Also draw in the faces. The girl, since she's young, will have eyes right in the middle of her head. Give her a nice straight nose and a smiling mouth—turn the corners up. Look in the mirror for the ear. If you can't do one that pleases you, paint her hair to cover it! Draw in the fingers and nails too.

For the cat's face, make the eyes high on the face and slanted upward, the nose long, and the mouth very near the chin. Also draw in the polka dots on the hat and egg so you get a precise idea of how they'll look.

Now take your #4 liner brush, dip it in Mars black acrylic, and you're ready to go!

Don't forget to paint in the black centers on the flowers and the little triangle shapes for the cat's ears and nose and the polka dots.

See pages 19–20 if you have any questions about outlining.

Shadowing

Put your canvas on a flat surface for the shadowing procedure. When your outline is dry (one hour or more), prepare a damp sponge with black *watercolor*. (To review the method, go back to pages 21–24.)

Rub the sponge lightly over your canvas in a circular motion. Let it dry for a few minutes. Then take your #1, ¼" flat bristle brush, dip it in water, and paint over the lightest areas. For this painting, do the butterfly, the girl's hat and face, the yellow egg, and the cat first. Leave a *thin* (⅛") border of shadow all around the edges. Blot with a paper towel and rub with your finger wrapped in a damp paper towel to remove all the shadow you don't want.

To shadow the face, remove a strip of shadow down the center of the nose, under the right eyebrow, and across the forehead. Remove all the shadow from the right cheek. Remove just a diagonal oval shape from the left side of the face. For the chin, remove a small horizontal oval shape. It's easy, and look at the wonderful results. For a new finishing touch, you can also mix a very light pink (white plus a touch of your favorite red) for the lips and cheeks. The irises are Thalo green with black pupils. When the face is thoroughly dry, add a tiny white highlight on the left of each iris. Use your *clean* liner brush for this detailed work.

Leave a wider shadow on the underside of the light portion of your leaves, under the cat, and on the right side of the vase. Remove a thin strip of shadow down the center of the stems.

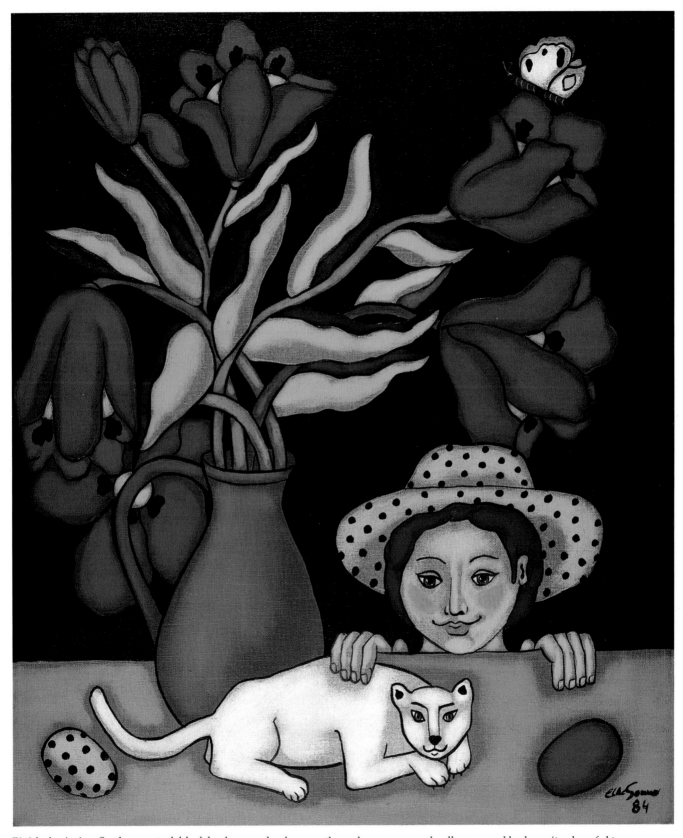

Finished painting. See how a stark black background enhances the reds, greens, and yellows—and looks quite cheerful too.

The Village Dance

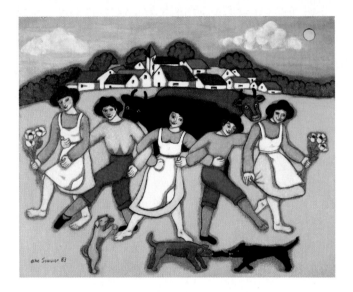

Introduction

Here's an invitation to kick your shoes off and come dancing. Most of my paintings are full of good feelings, but this one is especially warm and energetic. It's based on a favorite childhood memory—maybe that's why it's so inviting.

Equipment

Acrylic paints	Brushes
Titanium white	#20, ¾" soft flat
Mars black	#6, ³⁄₁₆" soft flat
Cadmium red light	#4, fine-point liner
Grumbacher red	brush
Portrayt red	#1, ¼" bristle flat
Hansa orange	
Cadmium yellow medium	*optional*
Yellow ochre	#4, ⅜" soft flat
Permanent green light	#1, ¼" soft flat
Thalo blue	
Burnt umber	

Watercolor paint
Ivory black

Procedure

Before You Begin

Notice how this composition has a central focus and spreads out like a fan. This is accomplished by lining up the tall church spire, the dark, very visible cows, and the middle, brightly colored figure right down the center. (Of course, they're not in a perfect straight line; that would be *boring*.) Also see how your eye is encouraged to move out from the center in *both* directions—most obviously by the two cows facing in opposite directions and the dancing figures who look like they might pull the poor girl in the middle in two!

Sketching—Phase 1

In this painting you're going to do your major sketching in *two* phases—both before and after you paint the background.

On your blank canvas draw or trace only the horizon line, the houses, and the trees—using your #2 or #3 pencil as usual. Erase if you need to and brush away the crumbs.

Painting In—Background, Houses and Trees

For the large grassy hill, squeeze a large amount of both permanent green light and titanium white onto your palette. Start with the white and add green to it with your largest brush (#20, ¾") until you get the soft, spring-like pastel shade you see here.

Paint over the entire area beneath the horizon. Make strong, generous strokes in a mainly horizontal direction.

For the sky, mix a large amount of white with very small amounts of Thalo blue and Mars black (because, alas, it's a cloudy day). Always put the colors on your palette separately at first, then mix them together with your brush a little at a time.

For the trees, mix your permanent green light with about half as much cadmium yellow medium or yellow ochre.

The housetops are different shades of Thalo blue—that is, Thalo blue mixed with white. In this case, start with a little blue and add a *very* little white for your darkest blue. Paint in two or three rooftops as you see here. Add more white for the next lightest blue, and so on. I have used four shades of blue on my rooftops. You mix whatever number *you* want. Paint the houses in white. Leave the little windows for later when you do the outlining. Rinse your brush out well every time you change colors.

Sketching—Phase 2

When your background has dried for *at least* one hour, it's time to finish your sketch. Are you wondering why you're sketching *over* the background instead of painting the background in around your sketch? Since there are so many little spaces in between the

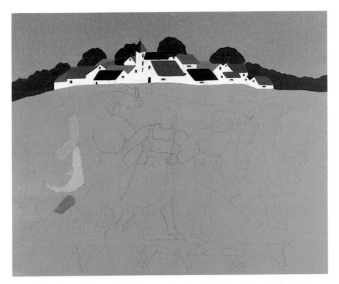

Here I've finished painting in the background and sketching in the figures and animals. I've applied only *one* coat of yellow to the girls' dresses. See how the green underneath shows through?

arms and such, it's much easier and neater to do it this way, rather than trying to fill in all those awkward little shapes. Luckily the green is light enough to paint over. You'll need only one coat to cover, except for yellows.

Now trace or sketch the rest of the drawing on the canvas. The figures should be touching—to give a warm and friendly feeling. If you're not too familiar with how cows look, note that their horns are above their heads, between their ears.

Draw the dogs any way you want. Mine are fighting over a "stolen" shoe. *You* might want to tell some other story.

Leave all the faces blank till later.

See page 16 for sketching tips; page 80 for tracing instructions.

Painting In—Figures

The girls' skirts are all cadmium yellow medium; their blouses are that same yellow with a very small amount of Hansa orange or cadmium red light added. Use your #6, ³⁄₁₆″ soft brush. Apply one coat, let it dry for ten to twenty minutes, then apply a *second* coat. While you are waiting for the first coat to dry, go on to the next step.

Now you can use your cadmium yellow to paint in the sun and a couple of the flowers.

The boy's stockings are a bright pure Hansa orange. You can add a very small amount of yellow to tone it down if you think it's too bright. (By now the girls' dresses are probably dry enough for a second coat.)

The boys' trousers and shirts are Thalo blue again. Mix your blue with a *little white* for the pants. Mix your white with a *little blue* for the tops. The colors do not have to be exactly like those you see here.

For the flesh color, add a small amount of yellow ochre and a tiny touch of Grumbacher red to a large

amount of white. Of course, you don't need an enormous amount of paint; when I say large, I mean relative to the other colors.

To finish up your figures, you'll need Portrayt red for their hair, white for their aprons and the remaining flowers, permanent green light (with a speck of cadmium yellow medium if you like) for the leaves and stems, and black for their hats and shoes. Wait till you are outlining to fill in the black flower centers.

Remember, always make sure a color is dry before painting over or next to it. When painting adjacent areas, the paint only has to be dry enough so that if you overlap a little it won't come up and spoil your new color. Usually acrylics dry to that extent in just a few minutes. You will learn to tell if your paint is dry enough.

Cows, Dogs and Clouds

Use your small (#6, ³⁄₁₆″) or medium-sized (#1, ¼″ optional) soft brush for all of the following:

All three dogs are shades of gray mixed from just black and white. The one on the right is black with just the smallest touch of white. The middle one is about half and half. The one on the left is white with just a small amount of black. The little pink tongue can be made from any of your reds with a little white.

The cows are both burnt umber. The darker shade contains a touch of white; the lighter shade a little more. The cows' lips are a pale flesh tone with more red added than is usual for flesh colors.

See how these clouds look like wide softened triangles?

To make them, dip your brush into some titanium white and "draw" a row of little *half* circles (with the closed side on top). Start with the tops of the clouds and make the row curved so that it comes to a peak in

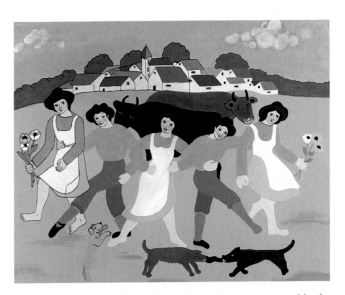

I'm almost done outlining here. Just take a minute and look at the difference in the areas I haven't gotten to yet.

Detail: Tree shadowing. The way I've done the shadowing here makes my trees look puffy and three-dimensional. To create this effect, remove the shadow by making tiny *circular* movements with your smallest bristle brush. Follow the scalloped outline of the tree along the edges. In the interior, make your circles at irregularly spaced intervals. Let them overlap. Make them different sizes. Variety creates more visual excitement.

the middle and then goes down again. Make two or three more rows, filling in the triangular shape. Leave space between the rows.

Now with your bare index finger, round out the half circles into complete circles. Where the paint is smeared with your finger, some sky color will show through, making your clouds look light, fluffy, and real.

See the detail on page 44 for more information on clouds. See pages 17–18 for further instructions on painting in.

Outlining

After waiting at least one hour for the paint to dry, you can begin outlining.

First draw or trace in the missing details with your *pencil*: the faces on the people, the dogs and the cows, the flower petals, the apron belts, trouser cuffs, and so

on. Also indicate the placement of the windows. Go over all the edges if you want.

Then go over your lines with a liner brush and Mars black acrylic. See pages 19–20 to review the outlining technique if you need to.

Also paint in the windows (see the detail on page 52) and the flower centers.

Shadowing

Wait for your outline to dry. Remember to put your canvas on a flat horizontal surface if it's not already. Apply the black wash and let it dry for a few minutes. Do not apply the wash higher than an inch above the treeline—do not cover the clouds.

As always, begin working on the lightest areas first—houses, aprons, and flesh. And don't forget to leave a ⅛" border of shadow along all the edges. See pages 21–24 for detailed instructions.

See the detail above to find out how to shadow your trees.

Notice that there are heavier, larger shadows under the two fighting dogs.

An easy rule to remember: painting your figures is a lot like dressing them. Put on their underlayers first, top clothes last.

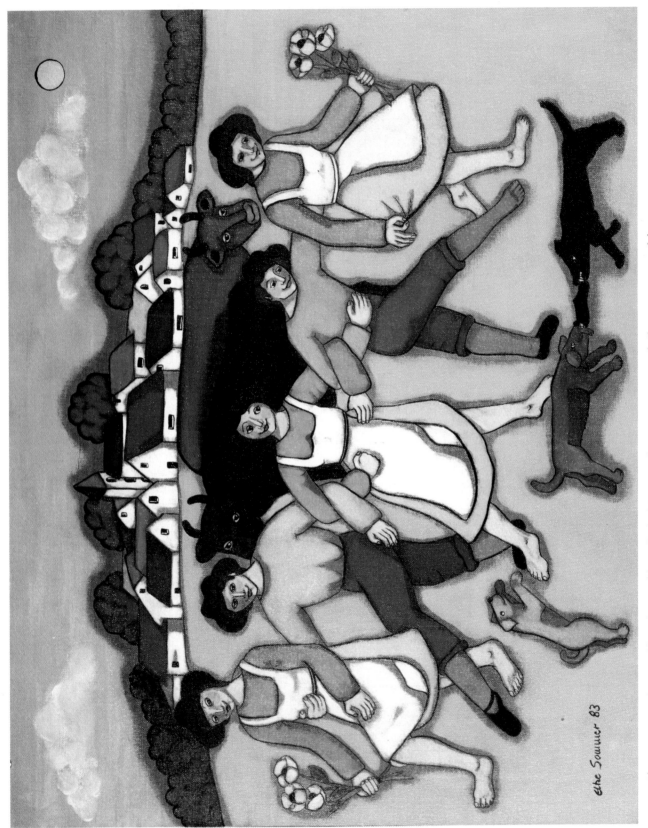

Finished painting: Lots of spring-like colors and friendly-looking people convey a sense of vibrant energy and fun.

Walking Over Water

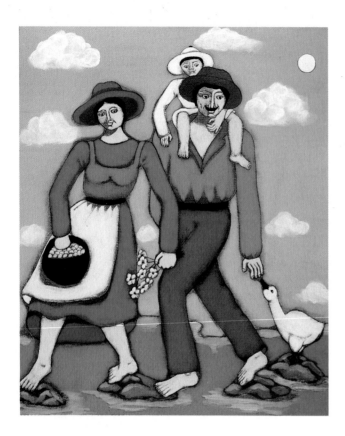

Introduction

This is a very whimsical painting. Did you notice that the woman is carrying a basket of *eggs* over those slippery rocks? She's not thinking about them, though. She's just having a good time with her family, enjoying cool summer breezes. There are lots of wonderful cool, breezy colors in this painting—aquas and blues which I'll show you how to mix.

Equipment

Acrylic paints	Brushes
Mars black	#20, ¾" soft flat
Titanium white	#6, ³⁄₁₆" soft flat
Grumbacher red	#4, fine-point liner brush
Yellow ochre	#1, ¼" bristle flat
Thalo green	
Thalo blue	*optional*
Grumbacher purple	#4, ³⁄₈" soft flat
	#1, ¼" soft flat

Watercolor paint
Ivory black

Procedure

Before You Begin

This composition has a central focus—the child on the man's shoulders—but its structure is more triangular than circular. Your eye moves in the direction the people are going—from the duck across to the left. Then your eye is led upward and back to the center by the direction of the woman's leg and the general diagonal direction of her body. Then the man's long, straight arm brings your eye directly back down to the starting point. Also, the duck, the woman's apron, and the child's hat provide nice white "corners" your eye can jump to.

Sketching

Sketch or trace your drawing onto your blank canvas. (See page 80 to learn how to make a tracing and page 16 for tips on sketching.) Don't forget, use a pencil that is not too sharp, especially if you are working on stretched canvas.

Spend time getting the sketch just how *you* want, because no matter how careful your painting, outlining, and shadowing are, they will mean nothing unless your basic drawing is good. A sketch is to a painting what a foundation is to a house.

You should leave details like faces, fingers and toes, eggs, and flowers for later, after the background is painted.

Painting In—Background

The sky is a combination of Thalo blue and titanium white. Start with white and keep adding blue to it with your brush. This sky is actually quite a deep, rich color, so don't be too timid with your blue. You can always add more white if your color gets too dark.

Paint in the sky around the figures using your #20, ¾" flat brush. Leave the clouds till later.

The water is a wonderfully cool and wet-looking aqua. Use white, Thalo blue, and Thalo green in about equal amounts. Use the same brush, cleaned, of course. (You will add the frothy waves later.)

Figures, Duck

Once your background is dry, you can really have fun with different shades of blue and aqua. Set your palette up in this way. Squeeze out large separate dabs of Thalo blue, titanium white, and Thalo green, and small dabs of Grumbacher purple and Mars black. You will be using these same dabs of paint to mix several different colors.

Now, with either your #20, ¾" or #4, ³⁄₈" brush,

Here I'm testing out some blues for the woman's dress and skirt. I changed them quite a lot by the end. Feel free to experiment like this yourself. You can make wonderful discoveries that way.

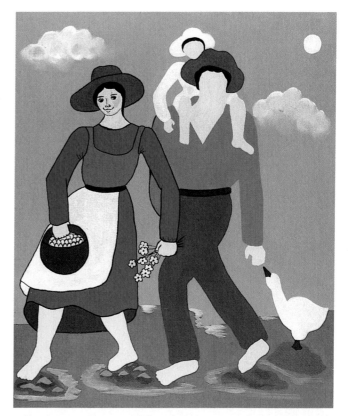

I've just put in some of the white water ripples, but I haven't yet smeared and softened the white with my finger. Compare this to the soft transparent effect you see in the finished painting.

make a separate mix containing equal amounts of white, Thalo blue, and Thalo green. So far, this is the same shade as the water. Add just a touch of black and use this color for the hats. For the man's pants, use this same mix and add another touch or two of black. Clean your brush.

Make another mix with slightly more Thalo blue than white. Again add the smallest touch of black and use this color for the woman's blouse. For her skirt and jumper top, mix equal portions of white and Thalo blue; add a small amount of purple and a touch of black. For the man's shirt, lighten this mix with some white. Rinse your brush again.

The woman's apron, the child's clothes and hat, the flowers, the eggs, the moon, and the duck are all pure white. The basket, the belts, the duck's beak and foot, and the figures' hair are all pure black. Use your #6, ³⁄₁₆" soft brush for these small areas. For the eggs, just paint the area solid white. The egg shapes will be indicated by *outlining* and *shadowing* later.

The flesh tones in this painting are *very* pale. Mix just a touch of yellow ochre and Grumbacher red with lots of white. Use your smallest flat brush (#6, ³⁄₁₆").

Rocks, Clouds and Water

The rocks are a simple black-and-white combination—about half and half. Also add a few dashes of a

darker gray and some pure white to give them dimension. Use your smallest flat brush (#6, ³⁄₁₆").

Remember, always wait for colors to dry before you paint over or next to them. Review the painting-in section on pages 17–18 if you want more information.

To make your water look frothy, paint a few streaks of white around the rocks and along the top edge of the water. Smear and rub with your finger so that some of that pretty aqua color shows through.

To learn how to make your clouds, take a look at the detail on page 44.

Outlining

Before beginning this stage, your painting must be thoroughly dry. Wait one hour at the very least.

Resketch your outlines in pencil if you want and trace or draw in the faces, fingers, toes, eggs, rock details, and flower petals. To draw the eggs, make rows of little scalloped "bumps." Notice that the rows are not directly on top of one another. Rather, they alternate like bricks. To make your rocks look bumpy, draw lines which start at the outside edges and arch across the top of each little white dash you've already painted in.

Also draw in a flower stem for each flower. Let them converge toward the woman's hand and then out again on the other side.

Detail: Clouds. With a clean brush dipped into pure white (use any size except the very largest), draw five or six little half circles (closed side up) in a curved row. Make another row or two underneath, depending on the size of the cloud. Make them irregular and uneven—like *real* clouds. With your index finger, rub the paint in circular motions. See how it becomes transparent and lets the blue show through. Leave the tops of the clouds thicker. Let more blue show through toward the bottoms. Use just your finger dipped in paint to make the very soft little clouds at the bottom. In general, put larger clouds on top and smaller ones below to give a feeling of depth and distance to your sky.

Now you can do your outlining, using a liner brush and Mars black acrylic. Refer to pages 19–20 for tips on outlining.

Shadowing

Place your painting on a horizontal surface and wait (an hour or so) for your outline to thoroughly dry.

Cover your canvas with black watercolor wash, following the technique given on pages 21–24. Don't cover the whole sky. The shadow only needs to extend a little outward from the figures. Although the black wash *will* come off, why spoil your pure fluffy clouds at all? It's not necessary.

Remove the black wash as usual, leaving a *thin* border around all the edges. Take away only a thin strip from the outer brim of the woman's hat. Leave the man's hat completely shadowed. Leave a thicker border of shadow under the basket, the apron, and the skirt—to add dimension. To indicate pleats and folds in her apron and his shirt, leave little triangular shapes of shadow extending from the belts and pointing downward and upward respectively.

On the eggs, leave a little touch of shadow on the bottom left of each one. Indicate the ankle bones by leaving a semi-circular wisp of shadow in the middle of the ankle.

On the rocks, leave shadow in and around the "bumps" you've drawn in.

For the faces and necks, note that the left sides remain in shadow. I didn't want them *too* dark, though, so when I was done, I took a clean damp paper towel and blotted with light *feather-like* dabs over the whole face. This softened and lightened the shadow considerably.

Don't worry about getting paint on your hands or nails. Both acrylics and watercolor come right off with soap and water.

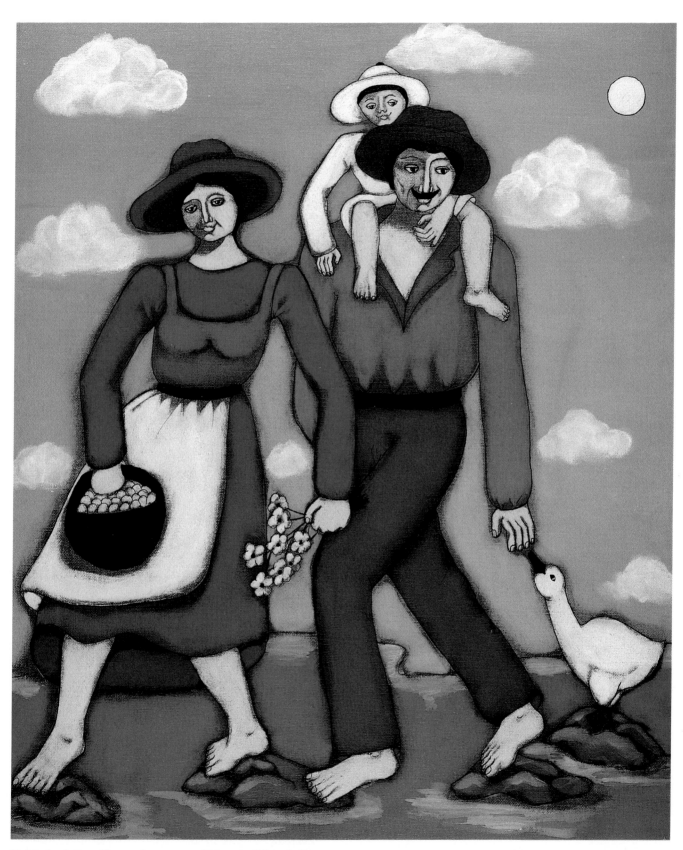

Finished painting. The cool greens and blues in this painting suggest, not sadness or coldness as you might suppose, but a warm, breezy, summer's day.

My Last One

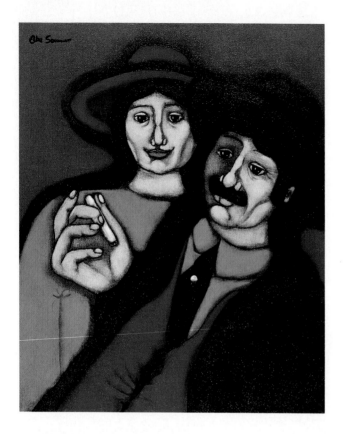

Introduction

My Last One is a study in grays and red. It's a little more solemn than most—with the man contemplating his *last* cigarette. The grays convey solidity and seriousness, making us believe he *really* means it. In this lesson you'll learn a new way to do your outlining—using watercolor paint and applying it *after* the shadowing. This produces a softer and more subdued effect—appropriate to the theme of the painting. You'll also find out it's easier than you think to make such wonderful-looking people.

Equipment

Acrylic paints	Brushes
Mars black	#20, ¾" soft flat
Titanium white	#6, ³⁄₁₆" soft flat
Grumbacher red	#4, fine-point liner brush
Cadmium red light	#1, ¼" bristle flat
Yellow ochre	
Thalo blue	*optional*
	#4, ⅜" soft flat
	#1, ¼" soft flat

Watercolor paint
Ivory black

Procedure

Before You Begin

This is an interesting composition. I wanted the "last cigarette" to be a major focus, and I also wanted to suggest some kind of story—maybe to make you wonder what the people were really thinking. To attract your attention to both the people and the cigarette, I placed their two faces and the man's hand at the corners of a central triangle. See? I also made them almost equal in color and size. Notice how your eye keeps moving from the faces to the cigarette and back again. Just what I wanted!

Sketching

Just draw or trace these imposing figures on your blank canvas. Leave the faces blank till after you paint in your colors. See the sketching tips on page 16 and the instructions for tracing on page 80.

Painting In—Background

For the background, mix a gray with about three times as much white as black. Add some Thalo blue a little at a time to produce the lovely gray you see here. Paint in your background with a large #20, ¾" brush. You won't need much paint for the background—the figures cover most of the canvas.

Hair and Clothing

Use your largest brush (#20, ¾") for the hair and clothing, except where indicated.

For the couple's hair, mix a dark pure gray, using just black and white in a ratio of about 2 to 1.

For the man's hat and jacket, start with this same shade of gray and add Thalo blue a little at a time until you can actually *see* the blue tint appear. (Notice how beautifully this contrasts with the pure gray.) Wash your brush now.

Her blouse and his shirt are a *much* lighter version of the blue-toned gray. Put a blob of white on your palette and add a very small amount of blue and even less black until you get the color you see here. Of course, your colors don't have to be exactly like mine. Maybe you'll come up with an even better mix.

For her hat and his vest, use cadmium red light straight out of the tube. Make sure your brush is clean.

The flesh tones consist of a large amount of titanium white and a touch of yellow ochre and Grumbacher red. For her lips, mix a pink with your Grumbacher red and white. Use your smallest brush here (#6, ³⁄₁₆").

The man's tie is pure black. His pearl tie clip and the infamous cigarette are white.

See pages 17–18 for tips on painting in.

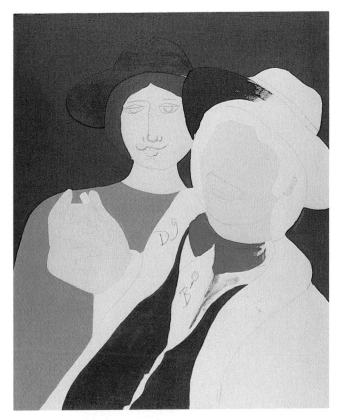

Here I'm just testing out my ideas for colors. Notice how I've indicated a possible choice by writing the color name in the appropriate area.

Option 1—Outlining Only

Is your paint all dry?

Here's your chance to take a shortcut or take on a challenge. Both will be fun and produce wonderful results.

If you choose the shortcut, take out your pencil and draw in the facial features and other details. Sketch in all the outlines if you want. Instead of your liner brush and black acrylic, however, you are going to use a waterproof marker. Choose one that's about the same thickness as the liner brush and go over all your outlines carefully, starting at the top left and working across and down. Don't forget, you can rest your hand on the canvas to steady it. Just don't smear anything.

When you're done, you can stop completely as I've done. See the finished painting on this page at the right. Note how clear and stark the colors look without shadowing. You may prefer this.

If you choose the challenge, try the following.

Option 2—Shadowing and Outlining with a Watercolor Wash

After you've painted in your colors, go straight to shadowing. Do *not* outline. Put your canvas on a horizontal surface and apply a black wash as you learned on page 21.

If you goof with acrylics or if your paint drips, wipe the area immediately with a damp paper towel. If you wait too long, you may have to paint over the area.

At this point, take your pencil and draw in the facial features, the fingers, little wrinkles by the eyes—and all other outlines if you prefer. You should be able to see your pencil line well enough even over the shadow.

Now take your liner brush and put in the outlines *over* the shadow using *black watercolor*, not acrylic. Why? Watercolor outlines give a softer, less bold effect—good for large facial details and in keeping with the more somber tones of this painting. Your watercolor should be the same consistency as the acrylic you're used to, but practice first on a separate piece of paper because watercolor feels and looks different than acrylic.

If you make a mistake, you can wipe it away with a damp paper towel. Then you'll have to reapply both the wash and the outline.

Now start with your lightest colors—the faces and the hand—and remove the black wash with your #1, ¼" flat bristle brush and paper towels. (See general instructions on pages 21–24.)

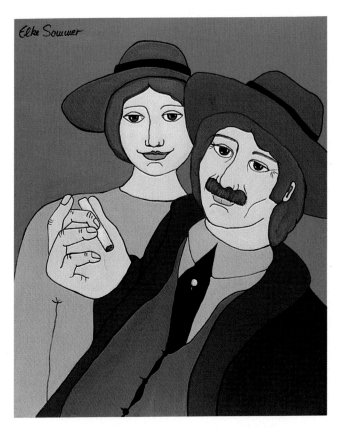

Finished painting—Option 1. In this version, a different effect was created by eliminating the shadowing technique.

47

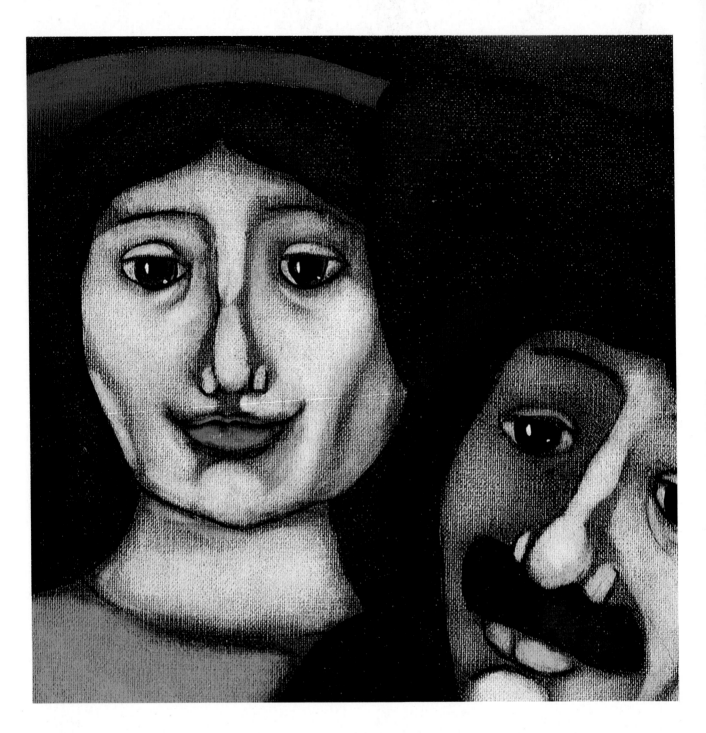

To learn how to create the wonderful character in the faces, see the detail above.

Shadowing the hand is really easy! The main thing to remember is to leave the shadow in the interior of the hand, between the fingers. The borders on the fingers should indicate where the fingers bend. Let your shadow come to a little point at each knuckle bend.

Remember to leave a thin shadow border along *all* the edges. Note that there's a thicker border *behind* the figures. On the hats, remove just a thin strip of shadow from the brim.

Detail: Shadowing the faces. Because the faces in this painting are so big, you can put in a lot of rich, beautiful details. Instead of our usual young people, we have a middle-aged couple whose faces have even more character. Shadowing is basically the same as for other faces, but notice the "bumps" on their noses. Instead of removing a straight strip of wash down the center of the nose, leave a little "bump" of shadow. Indicate the cheek bones by leaving a long curved line of shadow and the wrinkles under the eyes with *short* curved lines of shadow. Notice that the left side of the man's face remains totally shadowed. To soften your shadows when you're through, rub them with a slightly dampened paper towel in a very light, circular motion.

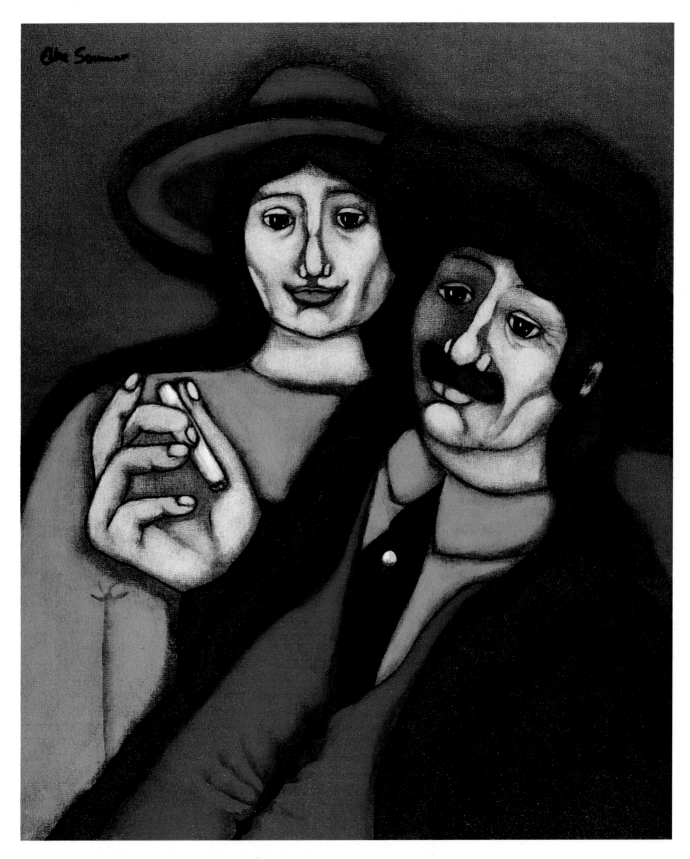

Finished painting—Option 2. In this version, the softer outlining was done in watercolor *after* the black wash was added.

A Sunday Afternoon

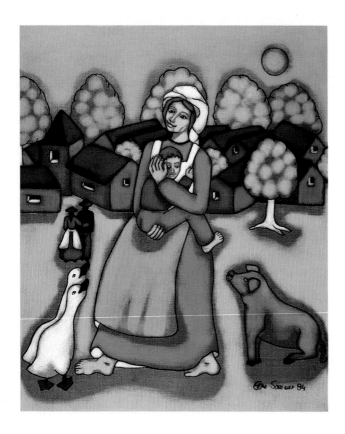

Introduction

Here's a painting for a quiet mood. The mother/child theme and the soothing pastel colors invite you to feel gentle and peaceful. I'll teach you to mix all these gentle colors. You can use them any time to make a calm and quiet painting of your own.

Equipment

Acrylic paints	Brushes
Mars black	#20, ¾" soft flat
Titanium white	#6, ³⁄₁₆" soft flat
Grumbacher red	#4, fine-point liner
Portrayt red	brush
Cadmium yellow medium	#1, ¼" bristle flat
Yellow ochre	
Thalo yellow green	*optional*
Thalo blue	#4, ⅜" soft flat
Grumbacher purple	#1, ¼" soft flat

Watercolor paint
Ivory black

Procedure

Before You Begin

Here, once again, is a composition with a central focus based on a triangular shape. Can you see it? The corners are the ducks, the pig, and the woman's head. Notice how the ducks and pig are looking upward—coaxing *your* eye toward the mother and child in the center. The darker colors surrounding the mother's white hat make her stand out even more.

By the way, if you don't think a *pig* is an appropriate animal for such a quiet, loving picture, then put in a friendly dog or cat instead!

Sketching

Draw or trace on your blank canvas, starting with the mother. Remember, an adult head is about one-seventh the length of the body, while a child's head is proportionally larger and more rounded.

If you're working freehand, surround your figures with pleasant country things or animals that *you* associate with calm, soothing, safe feelings.

Remember to round your trees and make them a little irregular to look more natural.

See the sketching tips on page 16 and the instructions for tracing on page 80.

Painting In—Background and Figures

Since there are so many colors and objects in this background, I'm going to list them one by one, giving you the color mixes for each. Paint in starting from top left and working across and downward. You should be comfortable with your largest brush (#20, ¾") throughout, except for the tiny figures, the tree trunk, and some of the smaller areas on the main figures. For these, use your #6, ³⁄₁₆" (or your #1, ¼" optional soft flat). See pages 17–18 for instructions on mixing colors and painting in.

Don't forget: Rinse your brush out well every time you change colors and make sure each area is surface dry before you paint next to it (wait five to ten minutes).

Sky: a large amount of titanium white with equal *small* amounts of Thalo blue and Grumbacher purple, plus a touch of black.

Sun: cadmium yellow medium, straight out of tube. This will need at least two coats to cover.

Trees: Make a mixture that is about equal amounts of Thalo yellow green, cadmium yellow medium, and yellow ochre. You can alter the amounts of cadmium

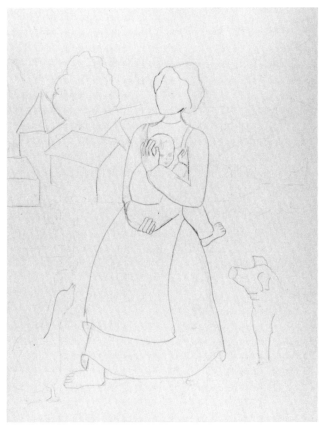

Here is just my initial sketch on blank canvas. It's not done yet. By comparing it with the following illustration you'll see I still need to do a little refining and straightening out on some of my shapes. You can put your sketch in roughly at first, too. Refine it later, after you're sure of the composition.

yellow and ochre for interesting variations. The one tree trunk you see is white.

Roof: Thalo blue with small amounts of white and black.

Houses: Leave these blank for now. Go back and paint them in with the purples and reds you'll mix for the mother and child's clothing. You can experiment here. Don't try to make your houses exactly like mine. Just remember to space or alter your colors so that the eye "jumps" around. Leave the windows until the outlining stage.

Ground: titanium white and yellow ochre in a ratio of about 2 to 1. Add a speck of Portrayt red.

Mother and child: Mix up a large batch of *light* gray, adding just a little black to a big blob of white. This is the basic color for all the blue and purple-toned shades. For the mother's apron, add just a touch of Thalo *blue* to part of your gray mix (see page 17 for instructions on mixing if you're not sure.) For her skirt and blouse, add a small amount of Grumbacher purple to another portion of your light gray mix. For the child's pants, add a little purple and a *touch* of Portrayt red to the gray. The child's shirt is Portrayt red with a little white. Now go back and paint in your houses with these same colors. If you want, add a touch of

black to each mixture to tone them down. Make sure you rinse your brush well each time you mix a new color.

The mother's apron top and hat are titanium white. Both her and her child's hair are Portrayt red—or use burnt umber with a touch of white.

For flesh tones, mix a touch of yellow ochre and a touch of Grumbacher red into a large amount of white.

Animals: The ducks are white; their beaks and feet a gray of half black, half white. The color of the pig is a mix containing a large amount of white and small amounts of Portrayt red and Thalo blue. Use a little more Portrayt than blue.

Little figures: Her dress is Portrayt red and a little white (same as child's shirt), and her apron is white. His pants and both their hats are the same color as the roofs. His jacket is black.

Outlining

Wait at least one hour for your paint to dry. It's better to wait longer, especially if you put your paint on thickly.

Sketch in your details with a pencil first. Sketch over all the outlines to provide a guide for painting, if you want. Notice how the tree outlines extend inward over each little bump.

To learn how to make those nice country windows on the houses, see the detail on page 52.

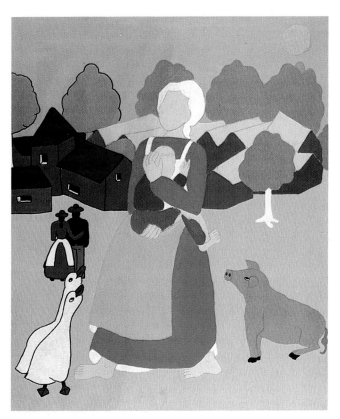

If you're *still* not convinced how much richness shadowing adds, compare this with the finished product!

51

Use your liner brush and black acrylic *or* your black waterproof marker. See pages 19–20 for a review of the outlining technique.

Shadowing

In this painting you are going to think about shadowing a little differently. You are going to use it not only to heighten your colors and add dimension but also to suggest true shadows from the sun. The sun here is *behind* the trees, houses, and people, so the shadows will extend out in *front*. The length of shadows indicates the time of day. Longer shadows suggest early morning and late afternoon. Pick whatever time of day you wish.

See pages 21–24 for instructions on preparing, applying, and removing a black watercolor wash. Make sure your painting is thoroughly dry. Lay it on a flat horizontal surface for this part. Use your #1, ¼" flat bristle brush to remove the wash, and have plenty of paper towels on hand.

There are a few special—and easy—shadowing effects here. On the trees, use your wet brush to make little irregular "polka dots" to suggest the soft round-ness of treetops. Dab and blot with your paper towels as usual. (See the detail on page 40.)

Since the sun is to the right of the painting, leave the houses shadowed on the *left*—the side the sun doesn't reach.

Leave a thick or long shadow under all the figures and objects. The shadow size should vary more or less according to the size of the object or figure casting it.

Also note the shadowing under the child and on the pig's belly.

Remember to leave a thin border of shadow along *all* the edges.

Detail: Country windows. Try this little trick I have for making three-dimensional country windows. First, paint in a square, rectangular, or curved-top window shape in black. Use your liner brush. When it's dry, pencil in an outline around each window. Stay flush with the black edges on the top and right; leave about ¹⁄₁₆" to ¼" margin (depending on your canvas size) showing along the bottom and left edges. Paint in the margin with white, using your (clean) liner brush. Let the white dry. Rinse your brush, and outline the whole shape with black. Add a little diagonal line to indicate the corner.

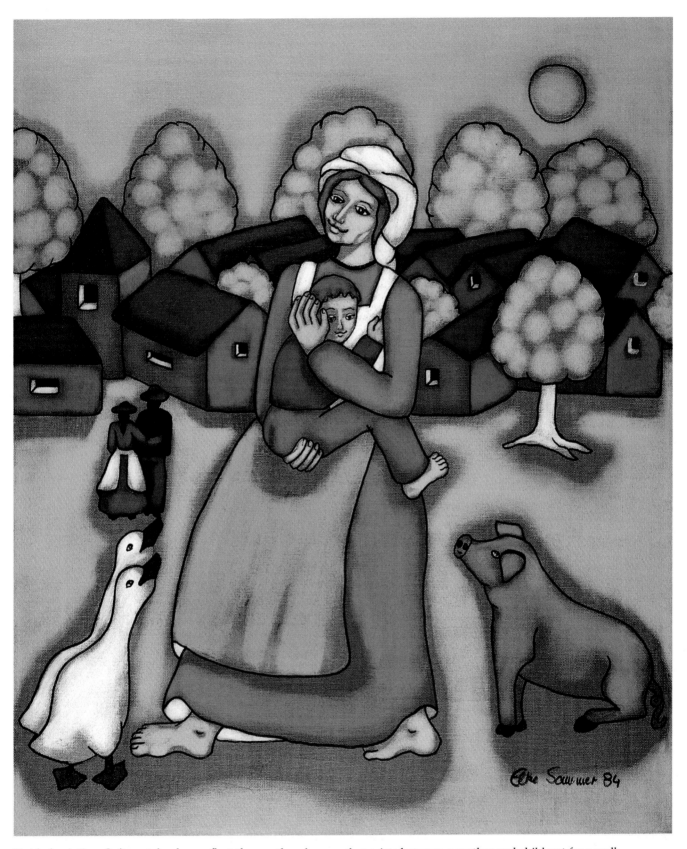

Finished painting. Soft pastel colors reflect the gentle calmness that exists between a mother and child out for a walk.

Clowning Around

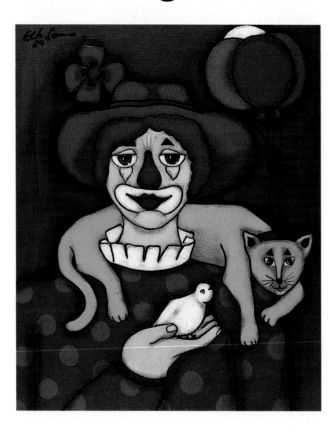

Introduction

The subject here is a clown, but really it's a chance to use a wonderful variety of different reds and pinks. I actually got my inspiration to combine these particular reds from looking at the flowers in a garden! Train yourself to *see* all the amazing things around you. You can use them in your paintings in the most surprising ways.

Equipment

Acrylic paints	Brushes
Mars black	#20, ¾" soft flat
Titanium white	#6, ³⁄₁₆" soft flat
Grumbacher red	#4, fine-point liner
Cadmium red light	brush
Thalo crimson	#1, ¼" bristle flat
Yellow ochre	
Thalo blue	*optional*
Grumbacher purple (optional)	#4, ⅜" soft flat
	#1, ¼" soft flat

Watercolor paint
Ivory black

54

Procedure

Before You Begin

The focus in this painting is all on the clown's unusual face. To give it importance, I've placed it near, but not in, the center of the canvas. (Things placed in the *exact* center usually look very static and boring.) The big cat, being the only light pink area on the canvas, also helps draw your eye to the face. See how I've used areas of white to move your eye through the center, too.

It's interesting to note that even though bold, happy colors abound, there's a touch of sadness in the clown's face that makes this painting more interesting and thought-provoking than a happy-looking clown would.

Sketching

Draw or trace onto your blank canvas as usual. (See page 16 for sketching tips and page 80 for tracing instructions.) Start with the clown's head. This time, don't wait to draw in the facial features—do it now. Since the face is so big and is composed of many areas of *different* colors, you can *paint* them in as you go.

Spend time on the face. It can be as weird and "unrealistic" as you want. You don't have to be Michelangelo to draw a clown face. Notice the triangle-shaped eyebrows, the wide, upturned mouth, and the odd-looking red nose. See the detail on page 56.

I'll give you a hint for making sad, soulful eyes. First, draw them *very* big and, second, leave some white showing beneath the iris. Remember, too, that you never see the *whole* circle of the iris in someone's eye—just a little more than half.

You can make the cat's face a little clown-like, too. I've given mine the same triangular eyebrows. (Leave the whiskers and outlines until later, though.)

Put a big floppy flower of your own invention in the clown's hat.

Remember, you can erase all you want—just brush away the crumbs.

Painting In

I'll give you the mixes for all the colors you see here. Use your #20, ¾" soft flat brush throughout, except for the smaller areas on the face. Use your #6, ³⁄₁₆" for

Take pride in your artwork even as a beginner. Always use good materials—cheap paints don't cover well. And put a nice frame on your work when you're done. It deserves it!

If your marker or outline brush skips, or if you don't get a smooth solid outline, don't worry. It will get filled in fine and smooth when you apply the black wash.

Here's just the sketch. I've put a lot of effort and attention into the face because it's the main focus of the painting.

can't go wrong with these reds. Try mixing any two or three of them together and see what you get. You can even add a touch of *purple* here and there. See pages 17–18 for a review of mixing and painting in if you need to.

Outlining

Start with your pencil and outline the details: flower petals, balloon strings, cat whiskers, fingernails, and so on. Outline everything in pencil if you want guidelines for painting.

Then paint them with your liner brush and black acrylic *or* use your waterproof marker.

Also use this brush to paint in eyebrows, nostrils, cat ears, bird beak, flower center, and pupils of the eyes.

When you've finished outlining, clean your brush, dip it in white, and add two highlights to each of the clown's eyes (on the left and bottom) and one to each of the cat's eyes (on the left).

these. Rinse your brush well every time you change colors. Make sure colors dry before painting in adjacent areas.

Background: Squeeze out a big blob of Thalo blue onto your palette and add a *little* white. Save a little of this color for your clown's eyes.

Hat: cadmium red light, straight out of tube.

Nose, mouth, collar on cat: Grumbacher red, straight out of tube.

Hair, flower, shirt, right-most balloon: Mix just a *tiny* touch of white into your Grumbacher red.

Balloons: The middle balloon is Thalo crimson with just a dash of white. For the left balloon use cadmium red light and add a little *more* white. The top balloon is pure white.

Cat: Mix a little bit of Grumbacher red into a lot of white.

Polka dots: Use a slightly darker version of the cat pink for the dots on the clown's shirt. Paint them *over* the red when it dries. Draw them in first if you want.

Eyes and tears: Both the cat's and the clown's eyes are Thalo blue with just a touch of white. The tears are white with just a touch of Thalo blue.

Flesh: As usual, mix a little yellow ochre into a large amount of white and add a touch of Grumbacher red.

Everything else is simply pure white. This is a good painting in which to make up your own mixes. You

Here you can see the painting in all its various stages at once. This is *not* the way to do it. I just wanted to show you—in one place—how a painting gets "built."

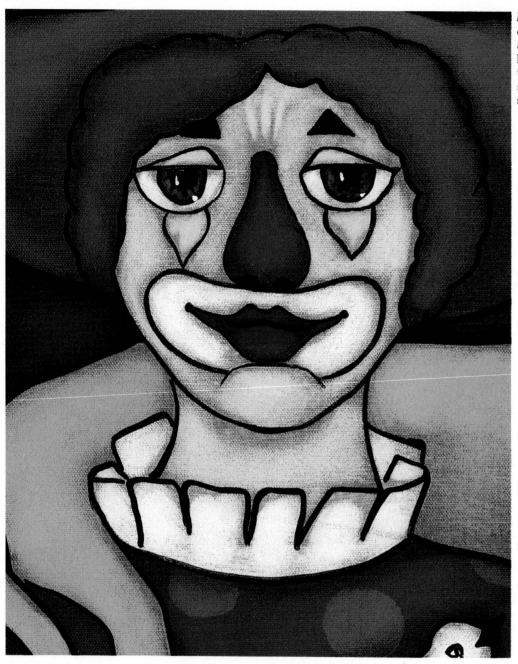

Detail: Clown's face. This closeup of the face will allow you to study all the little details: the sad eyes, the eye highlights, the shape of the mouth, the shadowing, and so on.

See pages 19–20 for a review of the outlining technique.

Shadowing

When your outlines are dry (one hour), lay your canvas on a flat, horizontal surface. Prepare your sponge and apply shadow to the canvas.

Let it dry for a few minutes and remove it, first with your wet #1, ¼" flat bristle brush and then with dampened paper towels. See pages 21–24 for complete shadowing instructions.

Remember to leave a thin border of shadow around *all* your edges. Remove all the shadow from the eyes and leave a thick band of shadow on the cat's belly. Notice how I've done the funny wrinkles between the clown's brow: just stroke three lines with your wet brush and blot.

An effective way to finish your paintings is to spray-varnish them when they're dry. The varnish protects the paint, especially a watercolor wash, from water and other kinds of damage.

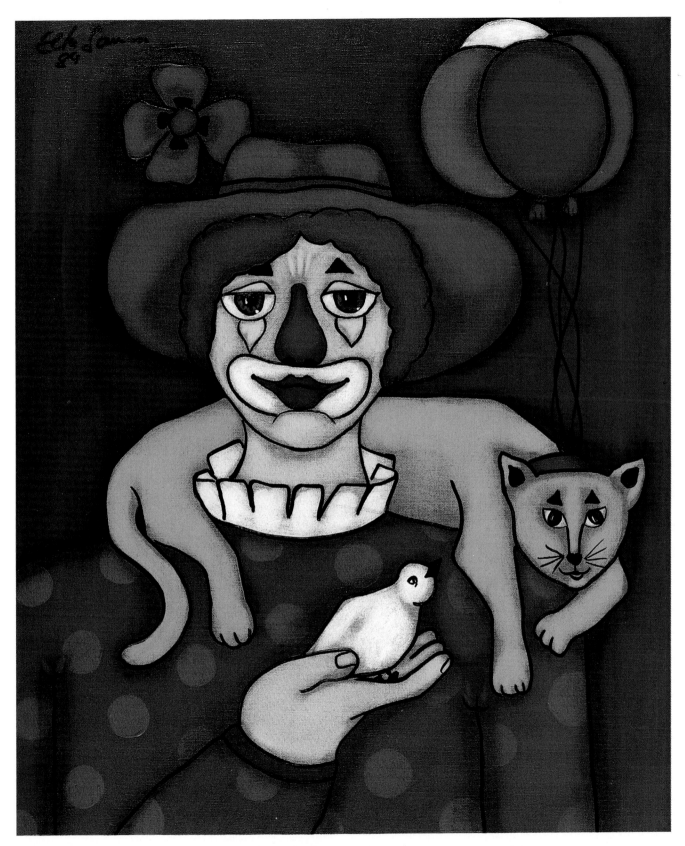

Finished painting: Lots of different reds all together make the
clown special. You will also have fun "inventing" your own
clown face.

Country Concert

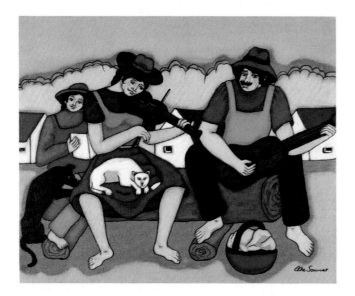

Introduction

I'll always remember all the pleasure I had being sung to as a child. In *Country Concert*, I again took a favorite early memory and made a painting based on it. This is not an *exact* representation of my memory, but it captures the *feeling* of it—with its soft, peaceful colors, snuggling animals, and contented-looking people.

This is a good thing to remember when *you* paint your own pictures. Look to your memories and imagination for ideas; don't worry about exactness; use colors and composition to express your feelings.

Equipment

Acrylic paints	Brushes
Mars black	#20, ¾" soft flat
Titanium white	#6, ³⁄₁₆" soft flat
Grumbacher red	#4, fine-point liner
Portrayt red	brush
Cadmium yellow medium	#1, ¼" bristle flat
Yellow ochre	
Thalo blue	*optional*
Cobalt blue	#4, ³⁄₈" soft flat
Burnt umber	#1, ¼" soft flat

Watercolor paint
Ivory black

Procedure

Before You Begin

Here I've put the people, the most important element of the painting, right in the foreground. They're sitting close together, expressing their warm feelings to each other—and to the viewer. As I often do, I've used color to move the viewer's eye where I want. Notice how the rusty reds keep your eye circling the musicians and how the blues make it jump across the canvas. By the way, think about how a bright cadmium red instead of the more subdued Portrayt would have changed the feeling of this painting. The colors you choose are *important*.

Sketching

Trace or draw freehand onto your blank canvas. Just sketch in the major shapes. Leave details like faces and guitar strings till after your colors are painted in.

If you're working freehand, feel free to change anything you wish to make the painting true to you. Look in the mirror at your own hands and feet—and remember they don't have to look *exactly* right.

See page 16 for tips on sketching and page 80 for instructions on tracing.

Painting In—Background

Use your #20, ¾" flat soft brush for all large areas. Switch to your #6, ³⁄₁₆" brush for tiny areas. Rinse your brushes well every time you change color.

Squeeze out a fairly large amount of white onto your palette and a small amount of cobalt blue. (Use Thalo blue if you don't have cobalt.) Add in a little blue at a time with your brush, then a touch of black. This toned-down sky is in keeping with the rest of the soft-toned colors.

For the trees, mix a large amount of white with small equal amounts of cadmium yellow medium and yellow ochre, plus a touch of Portrayt red.

For the rooftops, mix a little dab of white into your Thalo blue. The houses are pure white. Leave the windows until the outlining phase.

For the ground, mix white and yellow ochre in a ratio of 2 to 1. Add a touch of Portrayt red.

Don't forget: colors dry darker than they look when you first apply them. If you're trying to match a color, take this into account. Experience will train your eye.

I'm testing out my ideas for colors here. The sky and tree colors were easy to choose but I had to work at the "right" shades and placement of the reds.

Figures, Animals and Basket

For the girl's jumper top and leg, the woman's apron, the man's overall top, and the basket, you can use the same Thalo blue mix you used for the rooftops, or make up a new mix using cobalt blue. In either case, note that the apron and the basket are the darkest (have the least white) while his top and the girl's pants leg have lots of white. For this color, you will use less paint if you start with a dab of white and mix some blue into it.

Now take out that wonderful Portrayt red. Use it full strength for the brim of the woman's hat, her blouse, the underside of her skirt, and for the top of the man's guitar. Add just a *touch* of white for the woman's skirt. Add a little more white for the girl's hat and blouse, the top of the woman's hat, the man's hat, and the man's shirt. Add even more white to make the pretty pink for the woman's apron top.

See how *one* blue and *one* red can make so many different shades?

Use burnt umber for the man's hair and the sides of the fiddle and the guitar.

The girl's and the woman's hair, the top side of the fiddle, the basket handle, the dog, and the man's pants are all pure Mars black.

The cat and the songbook are white. The contents of the basket is that same cadmium yellow medium and white you used for the trees.

Flesh tones are made from titanium white with a *little* yellow ochre and the barest touch of Grumbacher red.

Logs

For the logs, mix burnt umber and white—about half and half, or mix a little Portrayt red with a lot of white and add Thalo blue until you get a soft, grayish brown.

See pages 17–18 for precise instructions on mixing and painting in.

Outlining

Wait for your painting to dry. Draw or trace in the faces and other missing details. Remember these are farm people—they work hard. Give them strong features. Also note the double row of trees. First outline the tops as you've painted them. Then draw in another row, following the general direction of the top outline. Make it slightly irregular and different from the top row. Don't forget the guitar, fiddle, and bow strings—just draw as many as will fit comfortably in the space.

For the log ends, make some little squiggly concentric circles. Give the people little ankle bones, too. Sketch over all the edges if you want precise guidelines.

Now you're ready to paint in your outline with waterproof marker or your liner brush and paint. Also do the windows (see the detail on page 52). For the violin strings, use white paint. Make *very* thin lines with your liner brush (see the detail on page 60).

See pages 19–20 for complete outlining instructions.

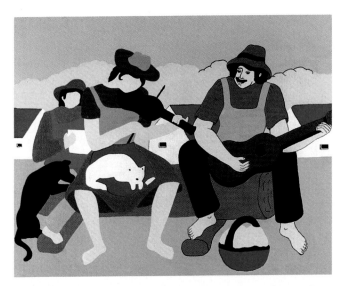

Here I've got my colors set and I've begun the outlining. By the way, doesn't *this* painting look brighter without the heavy shadowing? If you prefer this look, do a very light shadowing and remove all but a little under the log.

Shadowing

After your outline is dry, prepare your sponge with black watercolor and rub it lightly over the surface of your canvas. (See pages 21–24 for detailed instructions on all aspects of the shadowing technique.)

Start removing shadow from the lightest areas first. Leave a ⅛" border of shadow around all your edges. This does not have to be a precise border. It should be soft and not too noticeable.

Note that I let the shadow remain on the top row of trees and extended the shadow out in the sky in a wavy shape that echoes the "flow" of the treetops. Also note the large shadow remaining under the log and the little squiggly shadow shapes on the log ends.

Detail: Fiddle and bow. This closeup shows you how I've "strung" my fiddle. Note how the lines are very light, slightly squiggly and even broken in places. This gives you the impression they are vibrating with sound.

For something really different, try outlining and shadowing with blue, purple, red, or some other dark watercolor on one of your paintings. These different colors can produce some very intriguing effects. If you don't like it, you can always wipe it off with a moist paper towel and go back to black. Just make sure you use *watercolor*.

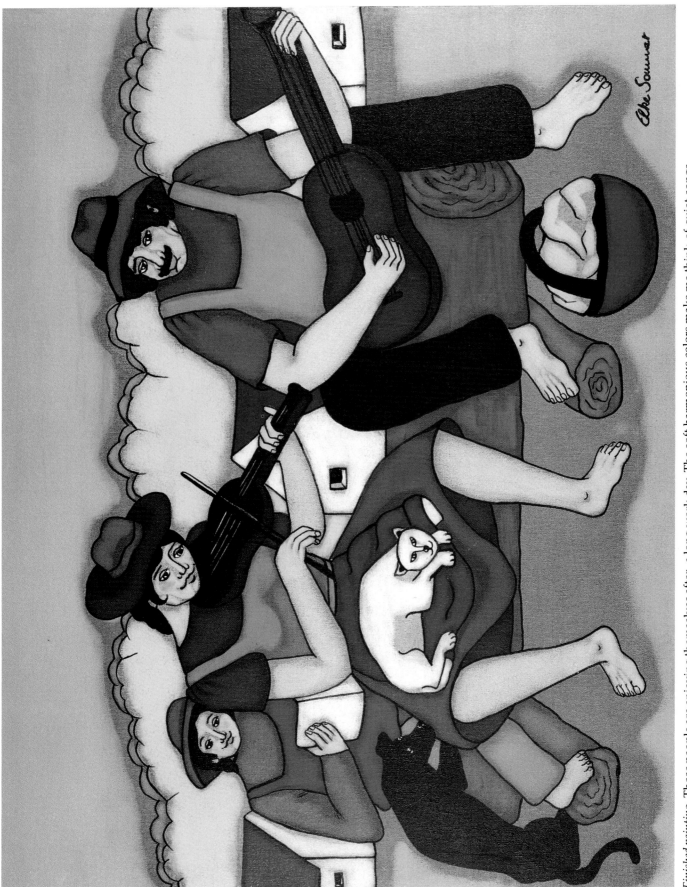

Finished painting. These people are enjoying themselves after a long work day. The soft harmonious colors make me think of quiet songs.

Spanish Wedding

Introduction

In keeping with this special occasion, I've used a very special new color—Thalo *silver*. Although it may look like plain old gray in the reproductions, it actually shines and glimmers like the real thing. You'll be using it to make a shimmery veil for the bride and quite a snazzy tie for the groom.

Equipment

Acrylic paints	Brushes
Mars black	#20, ¾″ soft flat
Titanium white	#6, ³⁄₁₆″ soft flat
Grumbacher red	#4, fine-point liner brush
Yellow ochre	#1, ¼″ bristle flat
Thalo green	
Thalo blue	*optional*
Thalo silver	#4, ⅜″ soft flat
	#1, ¼″ soft flat

Watercolor paint
Ivory black

Procedure

Before You Begin

First, I want you to imagine this painting without those areas of brilliant pink and red. (To have some idea how dull this would look, see the illustration on page 63.) It's amazing how just a few spots of well-placed color can create such movement and excitement.

And are you wondering why this painting has a *two-toned* background? It's because her light dress stands out best against a dark background while his dark jacket needs something fairly light to show *it* to best advantage. Sometimes your choice of colors will have nothing to do with the "real" world. You choose them because they work best *within* the painting.

Sketching

Draw or trace onto your blank canvas with your #2 or #3 pencil. Don't use a really sharp pencil and don't press too hard. You will scratch or indent the surface of a stretched canvas.

If you're working freehand, look in the mirror at your own hands—to help you get them right. To draw the lacy loops on her gown, see the detail on page 64. Make the red flowers very large and prominent. Leave the faces blank for now.

See page 16 for tips on sketching; page 80 for instructions on tracing.

Painting In—Background

For this two-toned background you'll need Thalo blue and titanium white. For the darker tone, add just the barest touch of white to your pure blue. It may need two coats. For the lighter shade, add a little more white. Use your #20, ¾″ soft flat brush. Paint the darker tone on the left of the bride, the lighter tone in all the background spaces to her right.

Flesh Tones

Paint the flesh tones of all the figures first. For their pale skin, use *lots* of white and only a touch of yellow ochre and Grumbacher red.

Bride and Flowers

Begin by painting the bride's veil, dress, and lily pure white. Use your #20, ¾″ brush for the large areas and your #6, ³⁄₁₆″ brush or even your liner brush for the lace. Give her apron two or three coats of silver (let paint dry between coats). Now go back and paint one coat of silver over her white veil (make sure it's dry!).

Here you can clearly see the two-toned background. Let the colors meet at the middle of the bride's head.

You can even go over the edges onto the blue. The transparent silver will let the color underneath show through—just like a real veil. Smooth the color with your finger for a really shimmery, soft effect.

The flower on her head is Grumbacher red with a touch of white for the darker front petals; add more white for the inner petals. Add just a little more white to this same mix for the waistband. You can paint the flower and belt on the little girl the same way. You might want to use your #6, 3/16" brush for all these small details.

The stem and leaves of the lily and the leaves of the red flower are a mix of half Thalo blue and half Thalo green with a little white. What a beautiful aqua this makes! Use this shade for the sprig of green in the groom's hat. Use your #6, 3/16" soft brush to paint these areas.

The bride's hair and the centers of both flowers are black.

Groom

The groom's hat, collar, and necktie are all silver. You'll need to give them two or three coats for the paint to cover. Let dry for a few minutes in between coats. His hat band, hair, shirt, and jacket are plain old black. His fancy handkerchief is white. How simple—no mixing at all! Use your largest brush for the large areas and your smallest where it's hard to reach.

Always let a painted area dry before painting over it or next to it. It doesn't have to be completely dry before you paint next to it—a five- to ten-minute drying period should be more than enough.

Little Girl

The girl's veil and dress are white; her hair black. Her waistband and flower are the same mix as the bride's.

Go back and touch up if necessary. Little irregularities can be hidden by the outlining and shadow.

See pages 17–18 for a complete review of mixing and painting-in techniques.

Outlining

Wait for your paint to dry at least one hour. Carefully outline the lacy loops you've made at the neckline and on the sleeves. To create the look of puffy sleeves and waistline, draw little V-shapes at regular intervals. Let the points touch the band. (See the detail on page 64). Also draw two curved lines to indicate the bride's breast.

Now draw or trace the faces in. If you're working freehand, give the man strong features—a nose with a bump and a bushy moustache and eyebrows. Notice that his head is turned slightly toward the bride. That

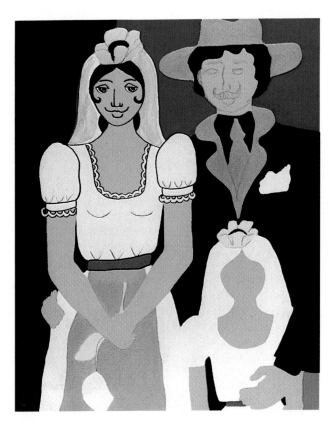

If you look carefully, at the left of the bride's veil you can see how transparent silver lets the blue beneath it show through. It *does* look like a veil, doesn't it?

63

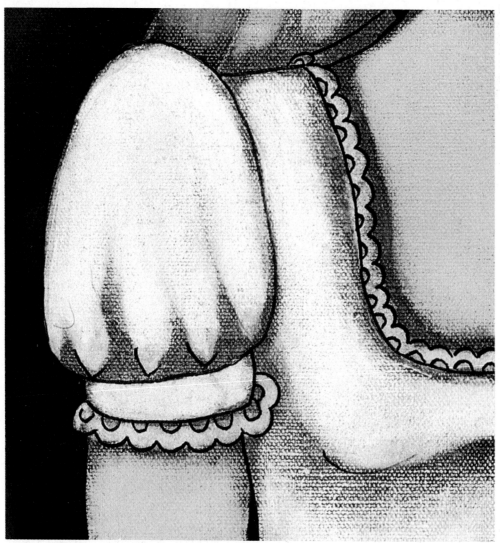

Detail: Lace. This closeup of the lace and the puffy sleeves will help you understand my instructions more easily. It's important that you paint your flesh tones in before you do the lacy loops. Think how tedious it would be to have to fill in all those little spaces with flesh color one by one.

means you'll see more of the left side of his face. Give him a cheekbone on that side.

The bride's face is more delicate. The child is very young, so you should give her a tiny little nose.

If you want to give yourself accurate guidelines, sketch over *all* the edges in pencil.

Don't outline the veils with pencil or paint!

When you outline with your paint, use your liner brush and black acrylic. Paint in the moustache and eyebrows and the black polka dots on the groom's tie, too.

Mix up a small amount of Thalo blue and Thalo green (about half and half) plus a small amount of white. Use your *clean* liner brush to paint the eyes of all three people this stunning aqua color. Clean your brush and add tiny white highlights on the left of the bride's and groom's irises.

See pages 19–20 for a complete review of the outlining technique.

Shadowing

Wait for your outline to dry. Place your painting on a horizontal surface. Apply the black wash to the whole surface of the canvas. (See pages 21–24 for complete instructions.)

Remove the wash from all the white areas first. On the veil, leave a few tapered, irregular lines of shadow, thicker at her shoulders and thinning as they go up.

For the puffy sleeves and waist, remove the shadow from *inside* the little V-shapes; let it remain underneath. Also leave a curved shadow underneath her breasts.

Remove just a thin strip of shadow from the groom's hat brim. On his face, remove the shadow from his nose, chin, and left cheek only.

On the red flowers let little specks of shadow remain here and there at the bases and the tops of the petals. This makes the petals look fluted and wavy.

Always remove all the shadow from their eyes.

Let a rather thick and definite shadow encircle the figures around the outside, but leave a thin, delicate border around the rest of the outlines.

Don't equate interesting or exciting with "perfect." Lots of times slight imperfections or personal quirks add uniqueness and impact to your work.

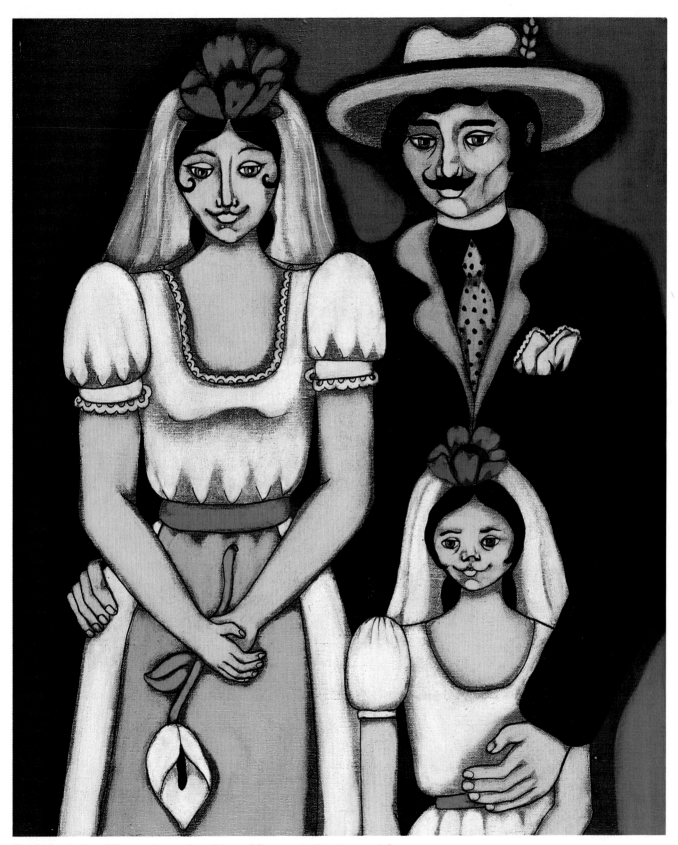

Finished painting. Silver paint makes *this* wedding portrait *extra* special.

Umbrellas in Love

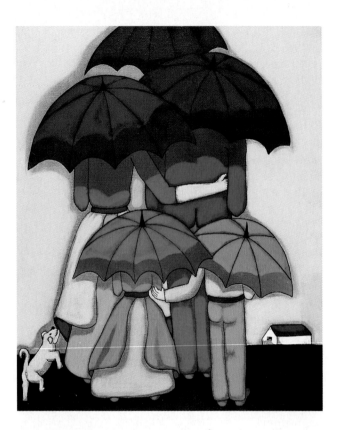

Introduction

In this painting you're going to discover the delightfully varied range of shades you can make from *one* color—just by mixing it with different amounts of white paint and applying my famous black shadow. That's right—except for the dog, the people's arms, and the white house, this entire painting was done using only one blue!

The effect is terrific and so simple. Notice that the blue I've used gives my painting a quiet, misty feeling. When I got the inspiration for this painting, though, I was in Spain, and it was hot and bright. People were strolling with umbrellas to protect them from the *sun*. If you're not having a "blue" day, try it with red, yellow, or green. Experiment, and see which colors will feel sunniest, happiest, or saddest.

Equipment

Acrylic paints	Brushes
Mars black	#20, ¾" soft flat
Titanium white	#6, ³⁄₁₆" soft flat
Grumbacher red	#4, fine-point liner brush
Yellow ochre	#1, ¼" bristle flat
Thalo blue	
	optional
	#4, ⅜" soft flat
Watercolor paint	#1, ¼" soft flat
Ivory black	

Procedure

Before You Begin

Look at the composition. The figures and umbrellas form an interesting pyramid shape that draws the eye in from the corners and up to the top center. To make this composition really work, I had to add a mysterious, floating umbrella on top! We don't know who is holding it. But that's all right; often both the artist and the viewer have to use their imaginations.

Painting In—Sky

Draw a line where you want your horizon to be—about one-fourth of the way up your canvas. Then squeeze out a *big* blob of titanium white on your palette and small blob of Thalo blue. Using your biggest soft, flat brush (#20, ¾"), mix a little of the blue into the white. Keep adding blue until you get a sky color that matches this one—or create your own. If it gets too dark, add more white, a little at a time.

Dip your brush in the water and then into your sky-blue mix. Use a generous amount of paint on your brush and stroke it smoothly across the canvas horizontally. Fill in the entire space up to the horizon line.

Sketching

When the sky background is entirely dry, you can sketch in the people, the dog, and the house right over the painted surface. Use the tracings provided in the back of the book or try sketching freehand. A #2 or #3 pencil is best, and if you are working on a stretched canvas, make sure the pencil point is not too sharp. Otherwise you'll create indentations on the surface. Don't be afraid to erase. It's important to get your sketch exactly right—that is, exactly the way *you* want it. Just make sure you brush all the eraser crumbs away before you paint. Don't sketch in the face on the dog or the ribs of the umbrellas yet—that comes later.

See the tips on sketching on page 16 and the tracing instructions on page 80.

Painting In—Ground

Clean your brush. Squeeze out a medium-sized blob of Thalo blue and paint in the ground. It's all right to overlap the sky a little bit, but wait until it's dry before you do. This area may need a second or third coat because Thalo blue by itself does not cover well.

Umbrellas and Figures

To paint the umbrellas and figures, you'll work from the top down and from dark to light. You'll start with pure Thalo blue straight out of the tube and add small

See how I paint in the different sections. (In the text I've suggested a slightly different order to follow than the one you see here, but the procedure is the same.) Here I've stopped to mix more paint for the woman's umbrella. It's better to mix enough to last, but you can stop and remix if you need to; just make sure you leave your brushes in water unless you're using one to mix with. If mixing takes longer than a minute or two, then wait for the paint to dry thoroughly before going over it. Painting over slightly wet acrylic doesn't work.

amounts of white for each successively lighter color. Working this way will save you a lot of paint.

Squeeze a big blob of Thalo blue onto your palette. Dip your #20, ¾" flat soft brush into the water and then the paint. Mix it around till it's a uniform consistency, then paint in the top umbrella. Follow the curve of the umbrella shape with your brush, and use the edge of the brush to make clean, smooth edges on your canvas. When you use Thalo blue by itself, you need to apply two or three coats to cover well. Wait a few minutes between each coat.

Rinse your brush. Squeeze out a separate, medium-sized blob of titanium white on your palette. Pick up a little with your brush and mix it in evenly with the blue till you get a color just a *little* lighter than pure Thalo blue. Your mix doesn't have to be exactly like mine, but you shouldn't let it be *too* light at this point. If it seems too light, just add more blue. Now cover the next lower umbrella. Add a little *more* white and paint the woman's umbrella.

Continue in this way, in this order: man's jacket, woman's blouse, girl's umbrella, man's pants, boy's

umbrella, girl's blouse and apron, boy's pants, girl's skirt, boy's shirt, and woman's apron. To go from the man's trousers to the boy's umbrella color, you are going to have to add more white than usual. Look at the painting and see for yourself how much lighter the umbrella is than the pants.

By the time you get to the last two areas, your color should be even lighter than the sky. Here you can start with a fresh blob of white and add just a touch of blue. You can also use your white here to paint in the little house.

Choose a dark shade for the waistbands, the underside of the woman's apron, and the roof of the house. For the shoes, pick a shade that will contrast nicely with the ground color. Notice how painting separated areas the same color invites your eye to jump around from place to place—giving your painting movement and vitality.

Now it's time to mix the flesh color: plenty of white, a little yellow ochre, and a touch of Grumbacher red. Mix it well and use it for the arm, the hand, and the dog. If you don't want your dog to be exactly the same, you can add a little more yellow ochre or red.

See the instructions for color mixing and painting in on pages 17–18.

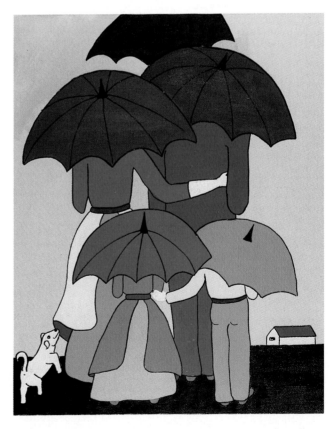

Here's the painting all filled in and almost completely outlined—before I've added the shadowing. Compare it to the finished painting to see how much liveliness and dimension the shadowing adds.

Detail: Shadows. Notice the wide, scalloped-shaped shadows along the rims of the umbrellas and across the figures' backs. This is not only decorative; the shadows also unify the composition by repeating the shape of the umbrellas. Also, as with colors, when you repeat the same or similar shapes in different places, you keep the viewer's eye from getting stuck in one place.

Outlining

When your painting is thoroughly dry (at least one hour), take up your pencil again and sketch in the lines that indicate interior details: the ribs of the umbrellas, the dog's face and paws, and other details. You can also draw pencil lines around the entire outline of your figures, their clothing, and so on. This provides a precise guide for you when you paint in your outlines.

Now squeeze out a medium blob of Mars black acrylic on your palette. Using a liner start at the top left, outlining the umbrella ribs. Make long, steady, free strokes. Proceed downward, outlining the outside edges of the umbrellas, the figures, and all the places where any two colors or shades meet and where you want to show some interior details. See pages 19–20 to review the outlining technique.

Rest your hand on the canvas for support, but make sure the paint is *dry* underneath your hand. You don't want to smear a freshly drawn outline.

With this same brush and paint, you can also paint in the umbrella points, the little dot for the dog's nose, and the window on the house.

Shadowing

When your outline is dry (wait at least one hour), prepare your sponge with black *watercolor* as you learned to do in the techniques section on pages 21–24. Rub the sponge in smooth, soft, circular motions over your painting. After the paint dries for a few minutes, take a clean, wet #1, ¼" flat *bristle* brush and stroke it over the lightest colors first (the sky, the aprons, and the flesh colors).

Dab the canvas with your slightly damp paper towel to remove the moisture. Then wrap a clean damp paper towel around your index finger and remove all the black paint that you don't want—pressing harder than before.

Now work on the umbrellas; then the figures. Leave a shadow which echoes the scalloped shape of the umbrellas on the bottoms of the umbrellas and on the figures' backs—a nice decorative and realistic effect.

Don't forget—never remove the color all the way up to the outline except in very special cases. Always leave a soft, thin shading along all the edges, even the outside ones.

Leave a slightly thicker shadow on the underside of the dog and under the woman's and girl's aprons. Also, for a professional-looking drapery effect, leave a couple of thin, irregularly shaped shadows on the girl's apron.

As you work on this fabulous shadowing effect, see how many new shades of blue are created. Count them—there are about twenty-six in all, from *one* original blue.

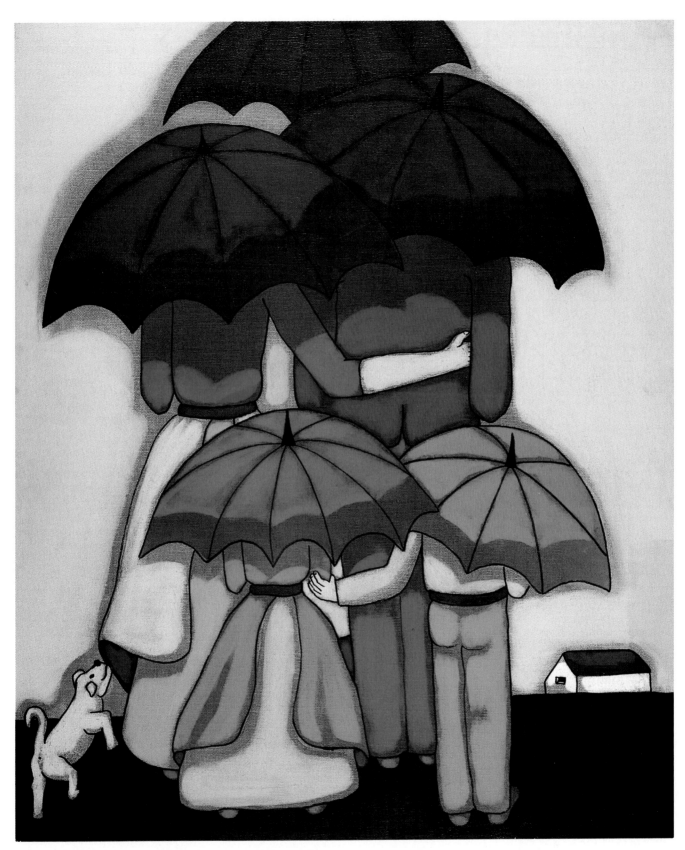

Finished painting. Here's a painting in which all the shades except the flesh tones and white are derived from one original blue. It's easy—try it.

New Tricks

Introduction

The title of this painting does *not* refer to *painting tricks*—but to what my friend taught her cats! Here you'll get to use lots of different reds together (as you did in *Clowning Around*), and you'll make these very smart cats even more extraordinary by painting them silver.

Equipment

Acrylic paints	Brushes
Mars black	#20, ¾" soft flat
Titanium white	#6, ³⁄₁₆" soft flat
Cadmium red light	#4, fine-point liner brush
Grumbacher red	#1, ¼" bristle flat
Thalo crimson	
Yellow ochre	*optional*
Permanent green light	#4, ⅜" soft flat
Thalo blue	#1, ¼" soft flat
Thalo silver	

Watercolor paint
Ivory black

It can be helpful to plan your colors in advance. After you finish your sketch, write the color name in the area where it will be. This is especially practical if you put your painting away for a few days.

Procedure

Before You Begin

Look at all the movement in this composition. It's quite lively—just as you'd *expect* leaping cats to be. Can you follow the circular rhythms? Notice how your eye sweeps upward with the help of the girl's bright red dress and the diagonal direction of her body. Then notice how it flies immediately downward again with the cats. The two *red* balls also coax your eye to jump back down.

To avoid the monotony of going round and round in circles, I also painted the rooftops on the little houses red. These invite your eye to rest for a minute away from the rather frantic motion.

Sketching

Draw or trace on your blank canvas. If you have questions about the procedure, see page 16 for sketching tips and page 80 for tracing instructions.

What you should note when drawing cats is how pronounced their haunches are and how long even the littlest cats look when they're stretched out. Draw any kind of scene you'd like to see in the windows—but include something there to paint that all-important red.

Leave the faces blank till later.

Painting In—Background

Use your #20, ¾" brush for all large areas. Use the tip of it for smooth edges and smaller areas. For very small spaces, switch to your #6, ³⁄₁₆" brush. There's no definite rule. Use the brush that feels most comfortable. Remember, always wait a few minutes for the paint to dry before painting the area next to it. See pages 17–18 for further instructions on mixing colors and painting in.

Mix up this wonderful blue from Thalo and white. Start with white and add blue to it with your brush. The sky outside the windows can be this same blue or just a little lighter (add more white). The windowsills and frames are Thalo blue with just a speck or two of white added.

Figure and Cats

Start with the undermost layer of clothing—the skirt. Paint it with cadmium red light, straight out of

I originally planned for one red ball, but I realized at this point that another one near the bottom would be a necessary addition. So I drew it in over the background. Just a tiny change like this can make so much difference.

the tube. You can also paint the hat, the two balls, and the little rooftops this same color now.

Rinse your brush. Squeeze out a little Thalo crimson onto your palette right next to the cadmium red light. Mix a tiny dab of cadmium into the crimson and paint the left portion of the apron that's sticking out behind the dress.

Now put some Grumbacher red on your palette. Add a touch of white and paint the blouse the wonderful deep pink that results. Add just a little more white to this mix and paint the front of the apron.

For that great hot pink jumper top, mix just a little white into pure Thalo crimson.

The hair, belt, and hatband are black.

The flesh color is made from titanium white, yellow ochre, and Grumbacher red. It's very pale; use a *lot* of white and only a touch of yellow ochre and red.

The cats are easy—two pure silver and two pure white. The silver ones will require at least two coats. Leave their faces and the stripes on their tails till the outlining phase.

Window Scene

The trees are permanent green light, the houses white, and the rooftops cadmium red light. The hills are—surprise!—*flesh* color. Use the mix you just made. Add a touch more red if you like.

Go back and see if any of your edges need to be smoothed or fixed. Remember, outlines and shadows will hide slight irregularities, so don't go crazy trying for absolute perfection!

Here are some general rules for placing eyes. An adult's eyes are about one-third down from the top of the head. A baby's eyes are right in the middle. A child's eyes are in between the two. Don't forget that the hair covers the top of the head. Take this into account when measuring.

Outlining

As usual, wait for your paint to dry thoroughly—at least one hour. Then draw in all your outlines with pencil and draw or trace in the faces, the stripes on the cats' tails, the little windows on the houses (see the detail on page 52), the stripes on the ball, and the cats' paws. If you're working freehand, remember that cat eyes slant upward.

Now dip your liner brush into titanium white and paint in the whites of the girl's eyes.

Outline with your *clean* liner brush and black acrylic—or take a shortcut and use your permanent marker. Rest your hand on the surface of the canvas if you need to steady it. Start at the top of your canvas and work across and down. That way, your hand won't smear any of the outlines you've just made. Clean your brush. Then dip it into permanent green light and paint in the irises of all the eyes and the band on the girl's braid. Remember, cat eyes have no whites.

See pages 19–20 for complete outlining instructions.

Here I actually removed the lower red ball again—I couldn't make up my mind! There's so much about painting that is just trial and error. Make lots of mistakes—you'll learn more.

Detail: Cat face and paws. Here's a closeup of one of those impish cat faces—and of the shadowing on the paw. A small detail like that shadow ridge at the joint will make your painting look very professional.

Shadowing

Wait for your outline to dry. Lay your canvas flat, and follow the instructions on pages 21–24 for shadowing and shadow removal.

In this painting, cover the whole canvas with a fairly light shadow. Use less than the usual amount of black watercolor on your sponge.

Use your #1, ¼″ bristle brush and begin removing shadow from the lightest areas first—as always! Leave a thick area of shadow on the cat bellies and under the leaping cats. Remove the shadow from the paws and legs, but leave a ridge of shadow at the joint. To create pleats on the girl's clothing, use your wet brush to paint out little V-shapes. Let all the shadow remain on the bottom of the windowsills. Leave a very light shadow on the right side of the girl's face.

If your shadow is still too heavy when you're done, take a clean damp paper towel and rub *feather*-lightly over the entire surface of your painting. This will lighten and soften your shadow considerably.

Finished painting. Lots of bright reds and silver create the excitement you'd expect to feel around mischievous leaping cats.

Summer Love

Introduction

I've saved a small shock for this last painting. Nothing *too* racy, just some innocent young love. Your *painterly* concerns, however, will be in creating the gently lapping, foamy waves and the "woven" basket.

Equipment

Acrylic paints	Brushes
Mars black	#20, ¾" soft flat
Titanium white	#6, ³⁄₁₆" soft flat
Cadmium red light	#4, fine-point liner brush
Grumbacher red	#1, ¼" bristle flat
Portrayt red	
Hansa orange	*optional*
Yellow ochre	#4, ³⁄₈" soft flat
Thalo green	#1, ¼" soft flat
Thalo blue	

Watercolor paint
Ivory black

74

Procedure

Before You Begin

Here, once again, is a *central* focus—the figures. They, together with the objects they're carrying, form a tight, closed unit for your eye to roam around. Notice that there are lots of repeated colors and shapes—the orange tones, the various reds, the stripes in his shirt and her towel, the two round baskets, and so forth. To unify the separate areas of the composition, I made the sun the same color as her hat and the sand a lighter version of the orange tones. The warm tones of the figures make an interesting contrast with the cool water and sky colors.

Painting In—Background

In this painting you are going to put the background in *before* you sketch. It's all light enough to paint over easily and will save some time and effort. Use your #20, ¾" flat soft brush. Draw a straight line for the horizon and a wavy one for the shore. Leave enough room for the figures to stand. Use the tracings if you prefer.

For the sky, use the now familiar Thalo blue and white combination. Start with the white on your palette and add blue till you get the color of a glowing, unpolluted summer sky.

For the cool aqua water, mix equal amounts of Thalo blue and Thalo green with about three times as much white as the combined blue and green.

Since you have plenty of room and no obstacles in the way, apply the paint generously in long, continuous strokes.

For the sand, mix white and yellow ochre in equal amounts.

Let each color dry before you paint right next to it. Otherwise your colors will smear. Rinse your brush well when you're done with each color.

Let the whole painting dry thoroughly.

Sketching

Now sketch in your figures with your pencil. (For information on sketching, see page 16. For tracing instructions, see page 80.)

If you're working freehand, remember that heads are usually about one-seventh the length of the body and that elbows taper to a point and are usually waist length. Let the baskets overflow with flowers and food. If you really prefer, give the girl a bikini bottom.

Painting In

Here is a list of all the color mixes you'll need for this

In this painting, you'll paint the background in first and then sketch over it. You can barely see my sketch; that's the idea with sketching. Light pencil lines are easier to erase and easier to cover with paint.

painting. Use your #20, ¾" brush for everything but the food, flowers, and hair.

Girl's hat, sun: cadmium red light, straight from the tube.

Girl's shirt: Grumbacher red with a little white added.

Boy's shirt: Hansa orange and a little yellow ochre.

Towel: same mix as the boy's shirt. The other stripes are pure white.

Boy's pants: about half Thalo blue and half white.

Hair: Portrayt red, straight from tube.

Flesh: Make your flesh mix from lots of white, a little yellow ochre, and a touch of Grumbacher red. The girl's skin is paler; use more white and less yellow ochre.

Food basket: The basket itself is pure white. For the bread, use the same mix as the boy's shirt. The wine bottles are Thalo green with a touch of yellow ochre; the vegetable greens are made from Thalo green and white (plus a touch of yellow ochre on the ones to the rear of the basket). You can make your fruits and vegetables any shade of green you like.

Flower basket: The basket itself is pure black. Paint the flowers pure cadmium red light, pure Hansa or-

Use cadmium yellow medium as your basic yellow. It's the only one you really need to have. Add white for a sunny, light yellow and a touch of red for a darker, heavier yellow.

ange, and cadmium red light plus a little white. Distribute the colors evenly; don't clump all the red flowers in one place. The flower centers are black. The leaves are Thalo green and white—about half and half.

Clouds: These clouds are all white, but sometime you should try gray or purple clouds like those you see in a storm. For these, dip your brush in white paint and draw a few curved rows of half circles, closed side on top. Then take your finger and rub the paint in little circular motions. Let the blue beneath show through on the bottom but leave the paint a little thicker at the top of the clouds. If you need to, add more paint to the top of the clouds with your brush. (See the detail on page 44.) Dip your fingers in water and wipe with a paper towel to clean them.

Ocean foam: For the foamy waves, use the same method, but apply the paint with your brush in horizontal streaks near the shoreline. With your fingers,

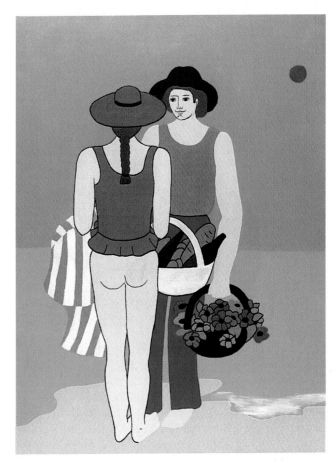

Here's another chance to *really* see just how much more interest and excitement the shadowing adds to your colors. Compare this to the finished painting.

75

Detail: Woven basket. Remove small dashes of shadow with your #1, ¼" flat bristle brush. Make a row across the top. Follow the slight curve of the basket. Dab with your paper towel. Make the next row down. Start your dashes in the middle of the dash above it. In other words, your dashes should look like rows of bricks—not one directly on top of another. Continue in this way down to the bottom. That's it—*really* easy!

rub up toward the horizon line, but in a *horizontal*, not vertical, direction. The paint will get thinner and thinner and let the aqua show through.

See pages 17–18 for complete instructions on mixing colors and painting in.

Outlining

After your paint is dry, give the boy a face—young and innocent! Put a few curved lines on the bread to indicate the curve of its surface. Make the vertical stripes on the boy's shirt. Also draw in the flower petals and a few lines to indicate the ruffle on the girl's shirt. Make tiny little loops along the bottom edge of her shirt. Draw two curved lines to indicate her buttocks. Outline everything with your pencil first if you need precise guidelines.

Now go over every line with your black acrylic and liner brush or your black waterproof marker. Don't forget all the stripes on the towel!

See pages 19–20 for tips on outlining.

Shadowing

Let the outlines dry and put your canvas on a flat horizontal surface. Prepare and apply the watercolor wash. You don't have to cover the entire sky and ocean, though. Just let your shadow extend an inch or two out from your figures (depending on the size of your canvas). *Do* cover the shoreline with shadow.

Remove the black wash as always. (See pages 21–24 for complete instructions on the shadowing process.) Note the thick band of shadow under the fold of the towel. Also note the little circular shadow beneath the couple's feet. This, by the way, emphasizes their closeness and, from its shortness, gives the impression that it's midday. On the ruffled edge of her blouse, remove little rectangles of wash, leaving lines of shadow to suggest folds. Leave the left side of the boy's face in shadow, as well as under his neck.

To make the "woven" basket, see the detail above.

Finished painting. Don't these wonderful colors suggest high noon on a midsummer's day? By the way, I hope you enjoy the slightly shocking humor here!

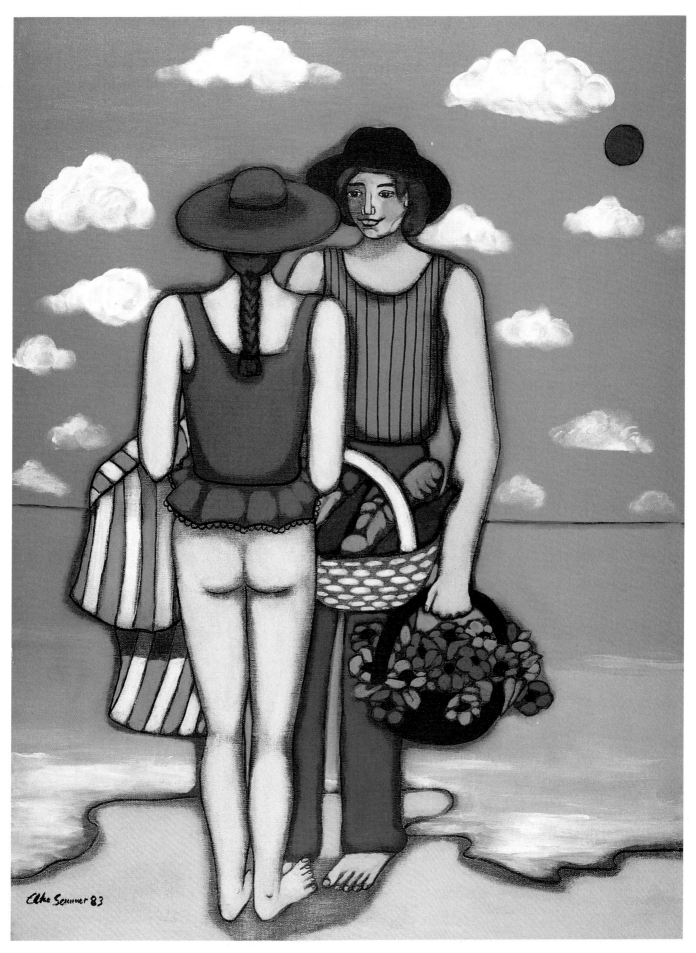

Enlarging Techniques————————

On the following pages, you will find tracings of the basic outlines of my paintings. You can use them as a guide for sketching, copy them right out of the book, or enlarge to fit any size canvas you like.

Using the grid. Each tracing has a light gray grid of squares printed over it for you to use as a guide for enlarging. It doesn't matter what size canvas you use, but you will find it easiest to use one that has the same proportion of width to height as mine. Simply divide your canvas into the same number of squares as you count on the tracing you want to copy. Use very light pencil lines to make a grid on the canvas so that it is divided into as many squares as the tracing. Now you can copy the outline square for square. It is best to begin at the top left if you are right-handed. Everything you see on one small square of the tracing is transferred, enlarged, into the corresponding square of the canvas. Erase the grid lines once you have finished copying the tracing.

Using a pantograph. The pantograph is a simple drawing tool used for copying, enlarging, or reducing original copies. It consists of four rods connected according to the instructions that come with it. When you use a pantograph, your left hand traces the original drawing and the enlargement is drawn by the rod system worked by your right hand. This method requires some dexterity with both hands but is easy to use for simple compositions.

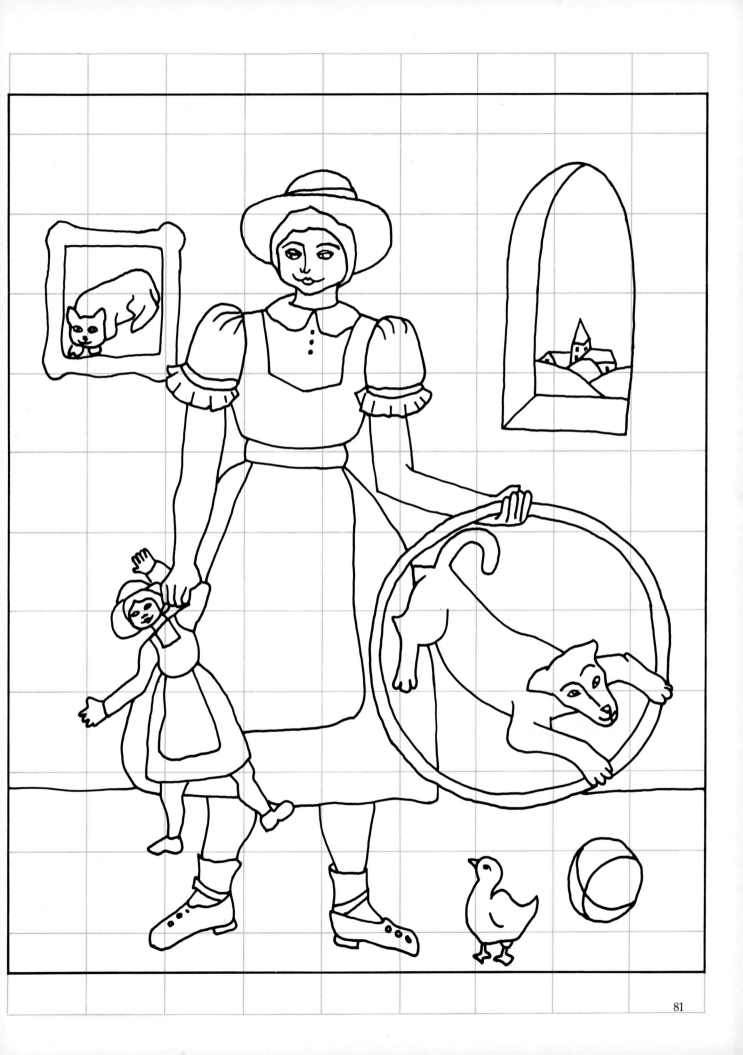

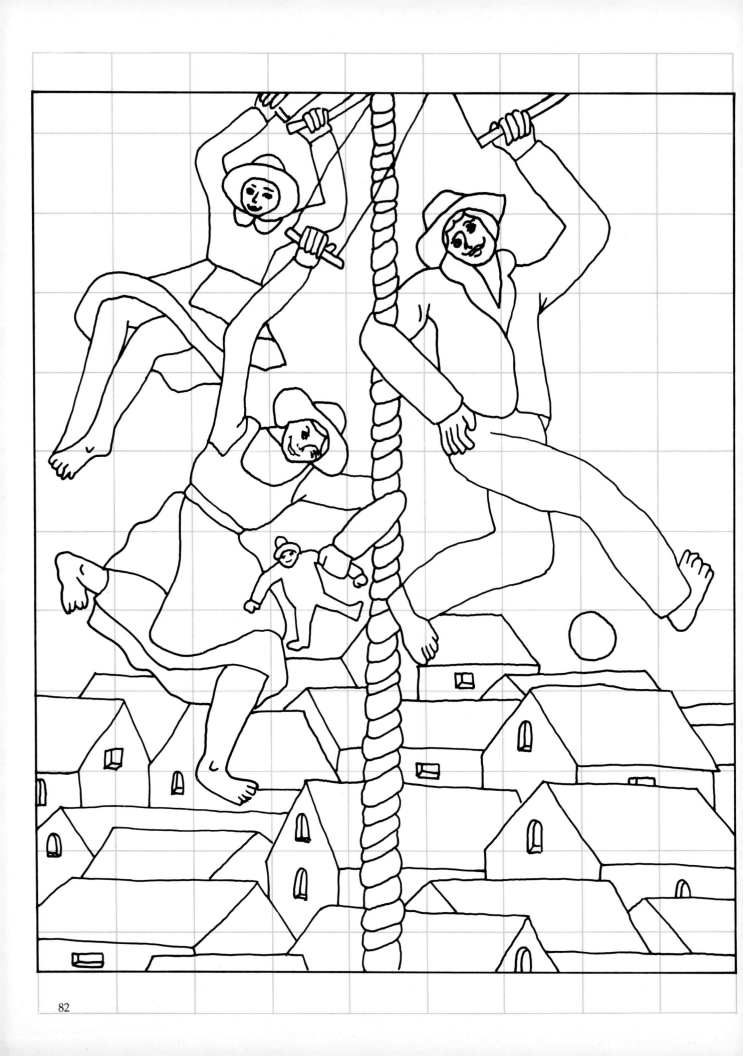

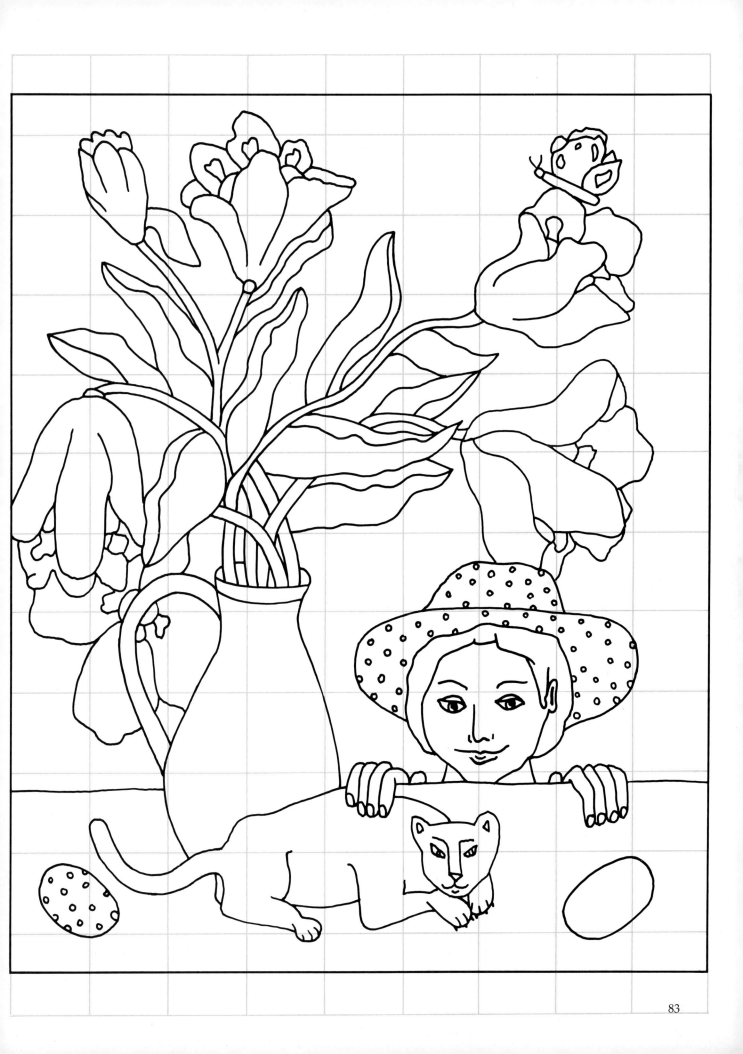

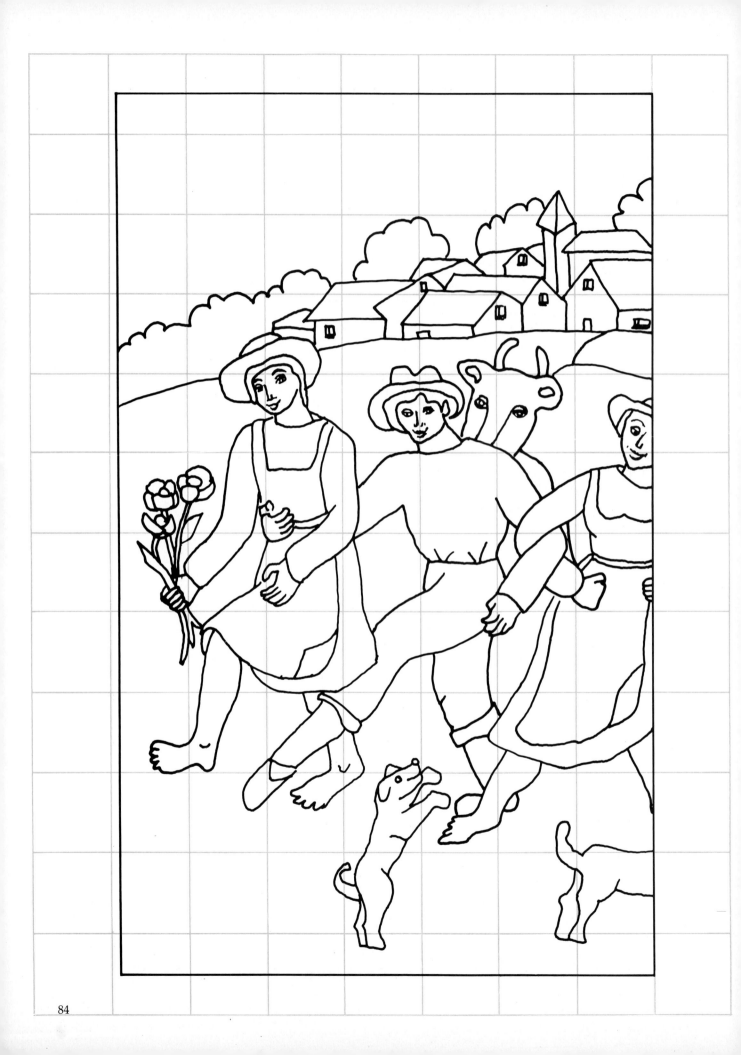

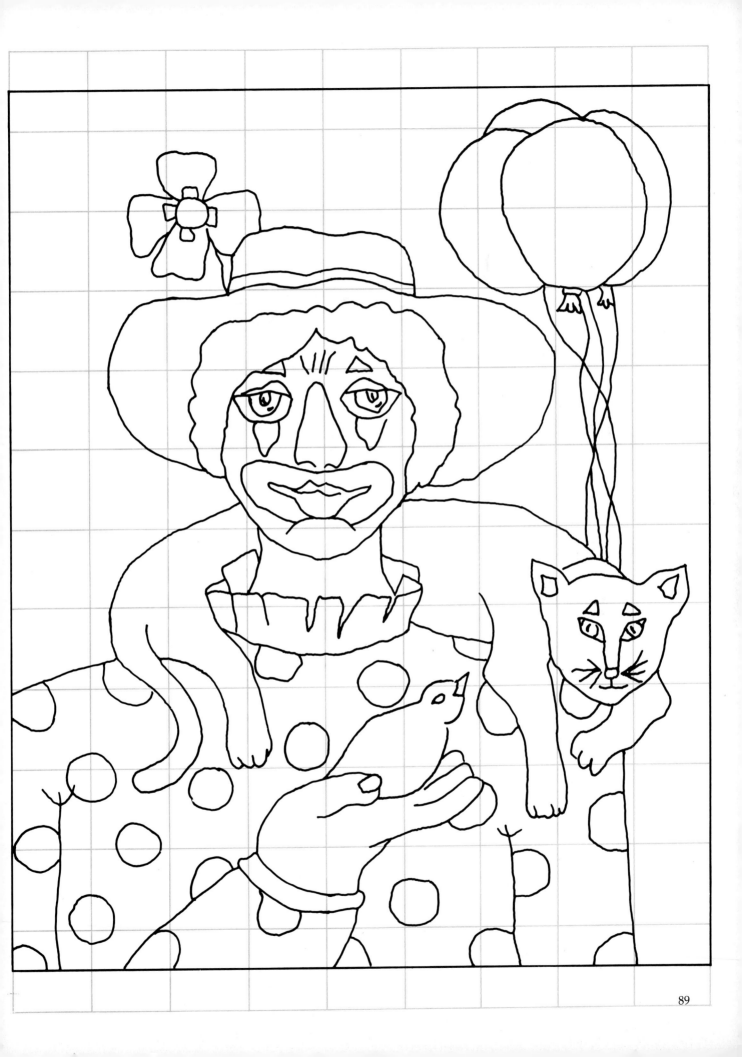

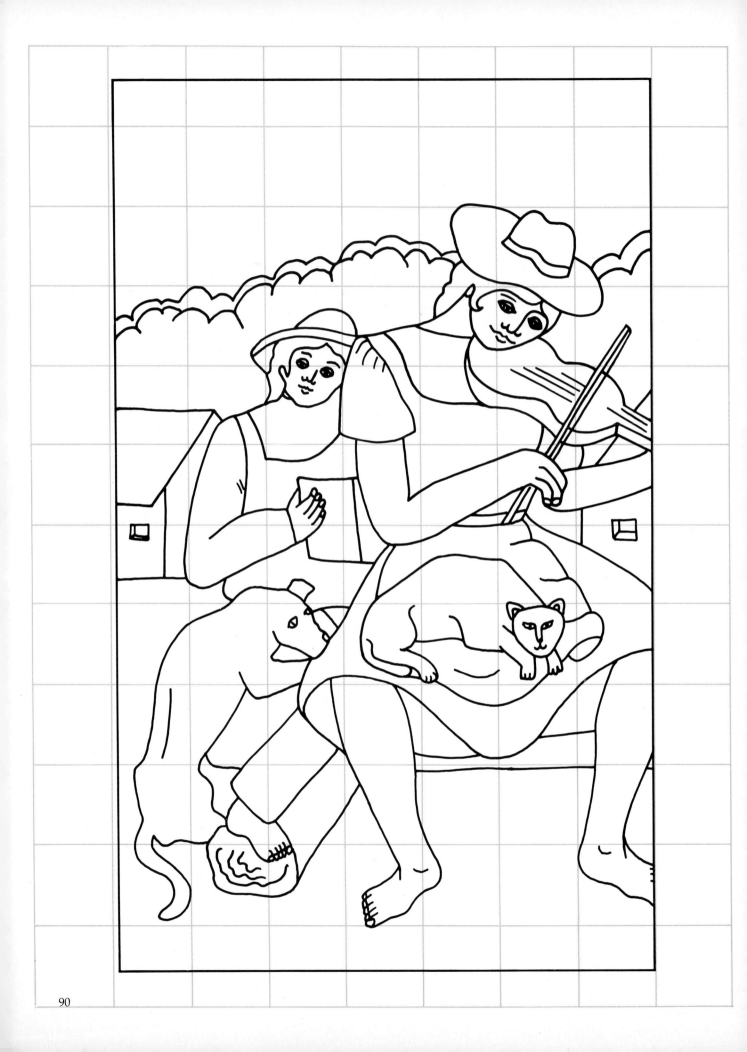

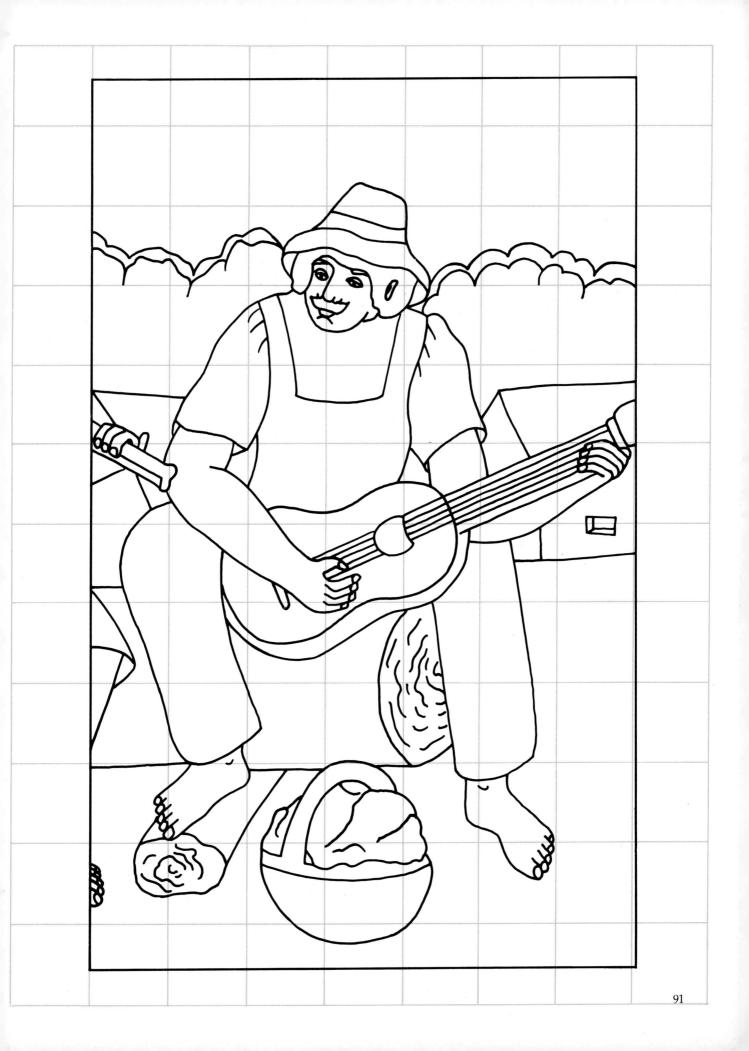

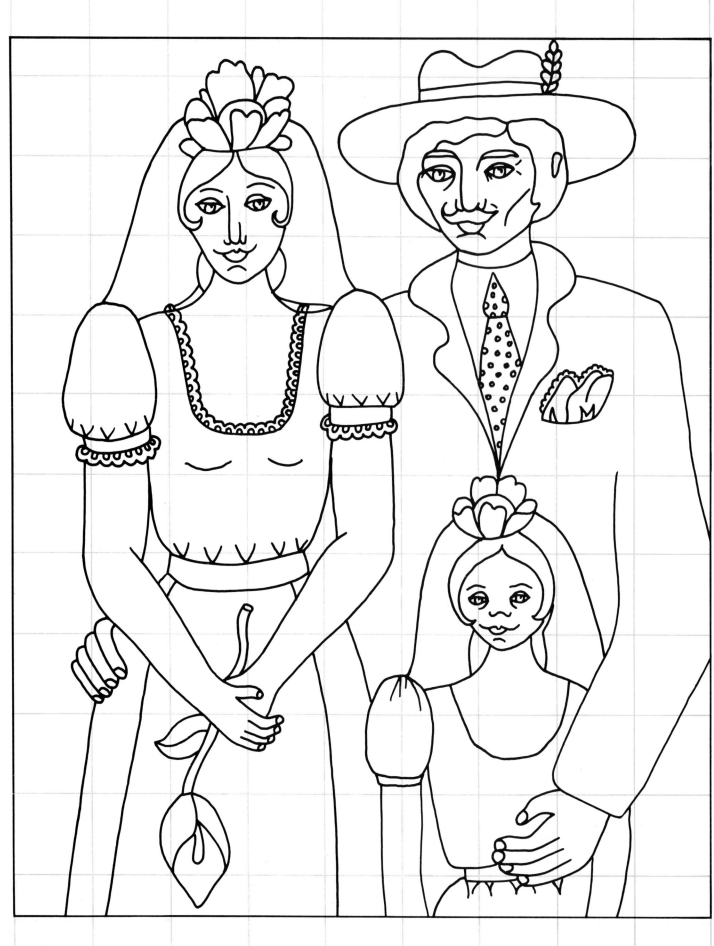

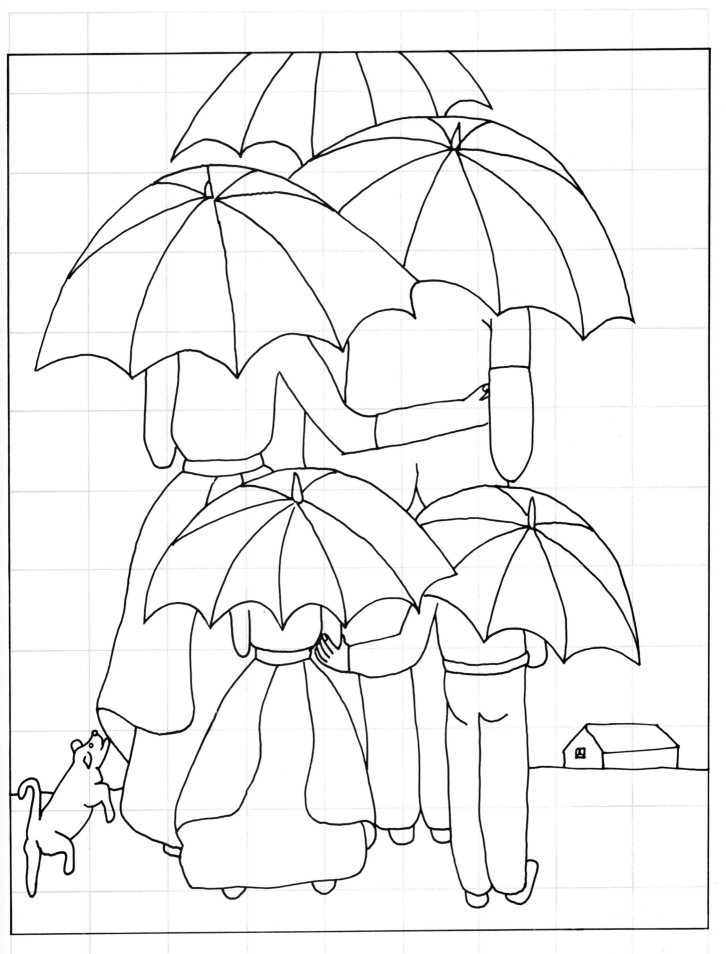

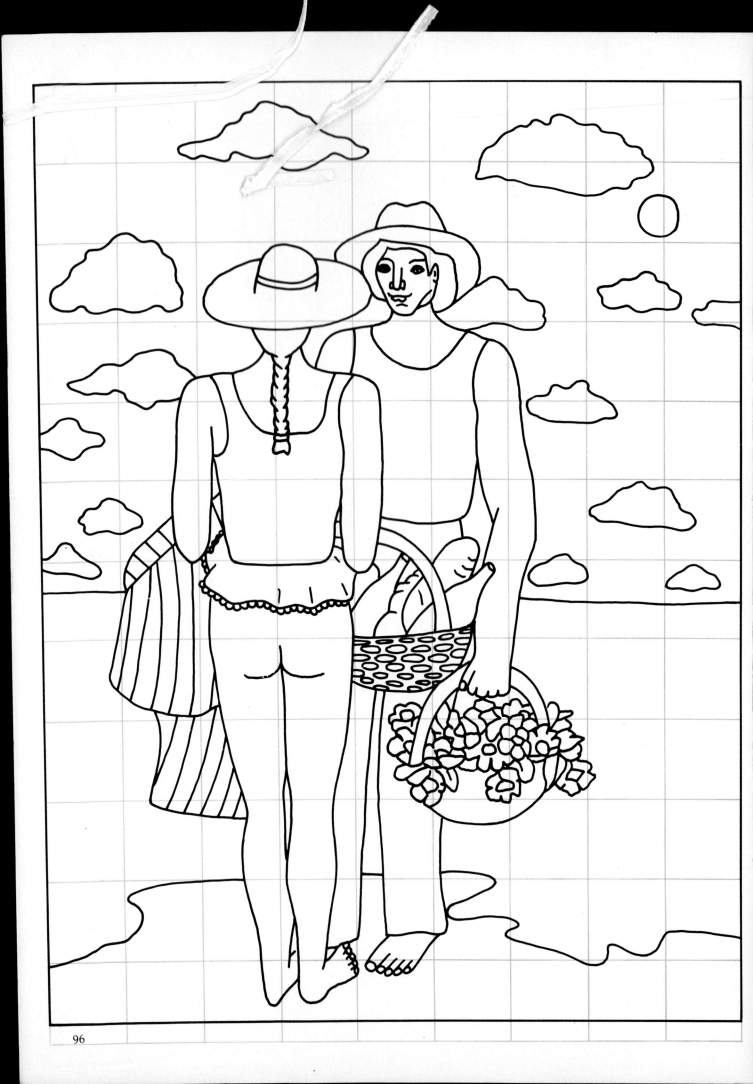